**AQA**

# Artists'

# Questions
# Answered
# Watercolor

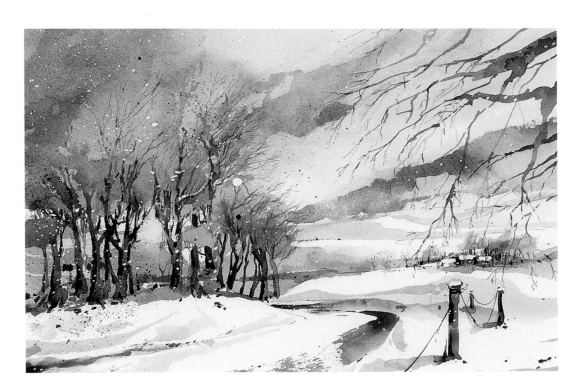

## DAVID NORMAN

Walter Foster

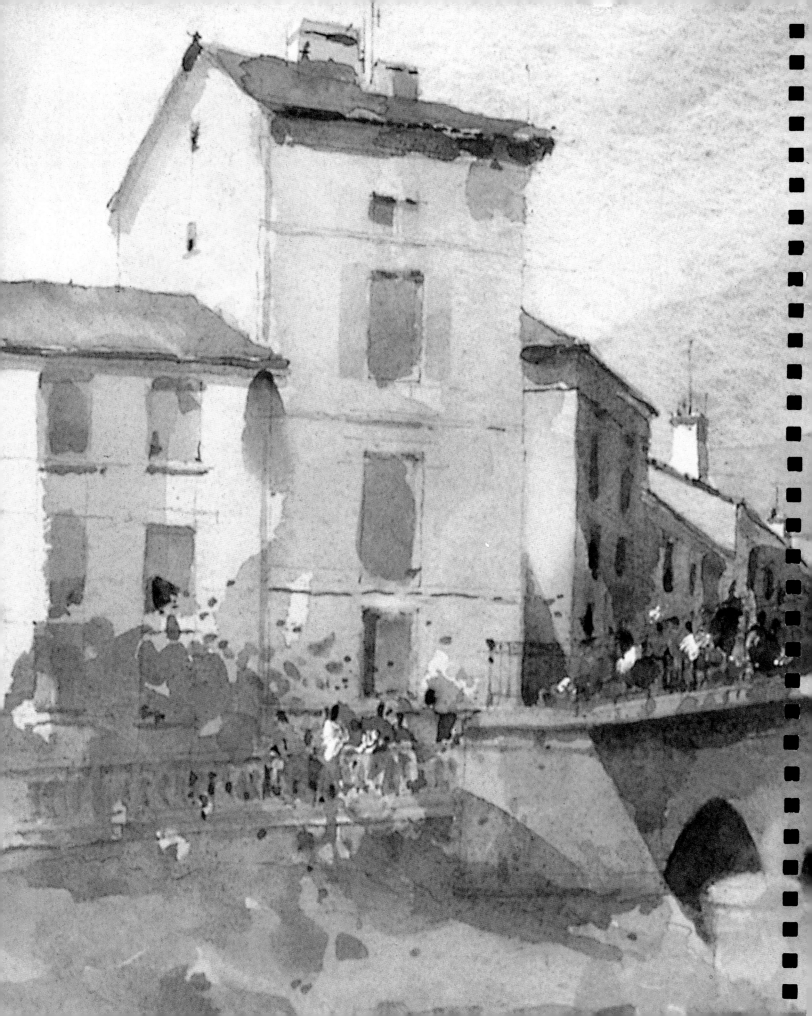

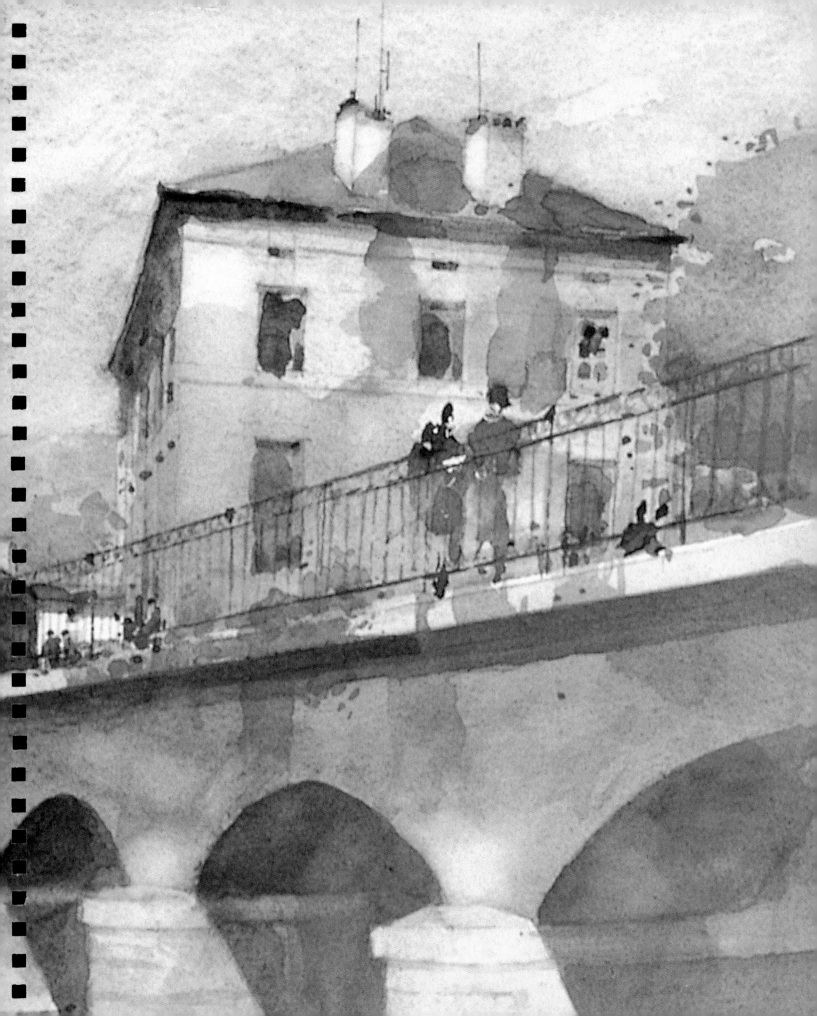

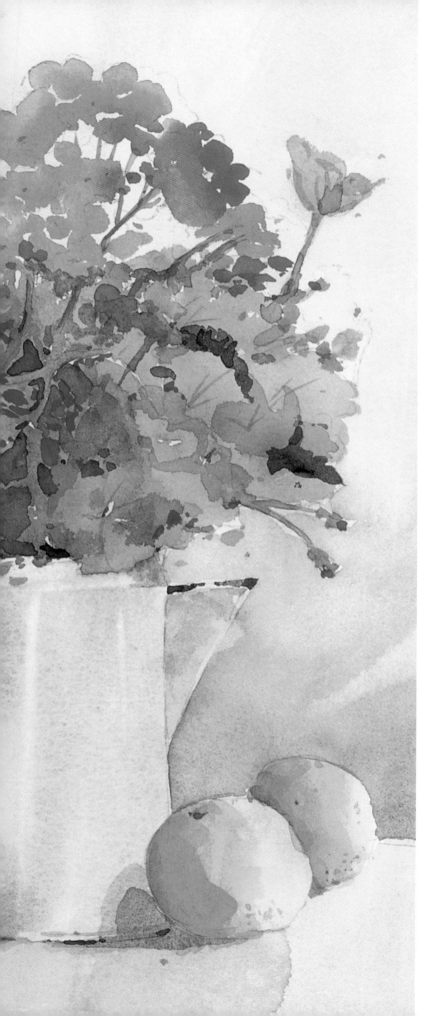

A QUINTET BOOK

Published by Walter Foster Publishing, Inc.
23062 La Cadena Drive
Laguna Hills, CA 92653
www.walterfoster.com

ISBN 1-56010-805-3

This book was designed and produced by
Quintet Publishing Limited
6 Blundell Street
London N7 9BH

AQAW

Senior Project Editor: Corinne Masciocchi
Editor: Anna Bennett
Designer: Ian Hunt
Photographer: John Melville
Creative Director: Richard Dewing
Publisher: Oliver Salzmann

Manufactured in Singapore by Universal Graphics Pte Ltd
Printed in China by Midas Printing International Limited

# Contents

# Introduction

Watercolor painting is a relaxing and enjoyable activity, and, with a little practice and perseverance, you will be able to produce beautiful and evocative paintings.

Do not be put off by any disappointments you may experience along the way. The important thing to remember is that watercolor painting is not as easy or straightforward as many suppose, and there will be many pitfalls and hurdles to overcome as you progress. The important thing is to enjoy the process of learning, which will enable you to improve your painting.

Like any discipline, watercolor painting has its rules. You do not have to stick rigidly to them, but some groundwork will enable you to express yourself in the way you would wish.

Understanding paper types, stretching paper, paints, the types and uses of brushes, mixing palettes, and setups for painting indoors or out will all help you achieve a greater understanding of your craft.

It is assumed you have acquired knowledge about sketching, paper, and general information about brushes and other watercolor equipment and materials, so the main aim of this book is to look at the problems you have now probably come across in your watercolor painting.

Each chapter highlights both areas of interest to most watercolor artists and areas where mistakes are often made. For problems that need a more detailed explanation, demonstrations are included, taking you step by step through their solutions.

There is, of course, no complete or definitive answer to problems associated with watercolor painting, and you will find selected works from many different watercolor artists with many different styles throughout the book.

No one can expect to be able to paint without practice and—most important—without some degree of experimentation. This book will help you with common problems and perhaps inspire you to look at different approaches to your watercolor work. Stay with it; watercolor painting is immensely rewarding and well worth all the effort.

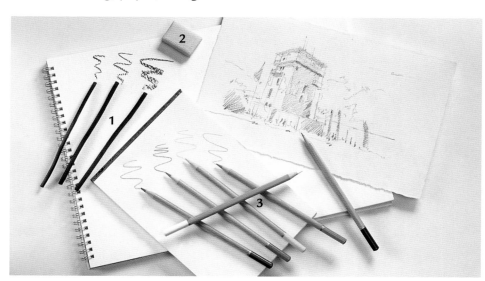

**◀ DRAWING EQUIPMENT**
1 Charcoal sticks
2 Kneaded eraser
3 Colored pencils

**▶ MASKING FLUIDS**
1 Masking fluid with applicator
2 Permanent masking medium
3 Masking fluid
4 Crow quill or mapping pen

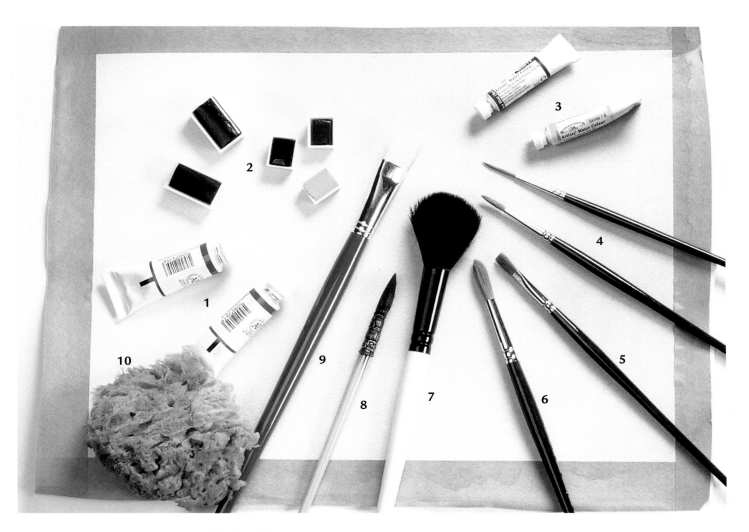

## ▲ PAINTING EQUIPMENT

1. Watercolor tubes (large)
2. Whole and half watercolor pans (cakes)
3. Watercolor tubes (small)
4. Rigger and small round
5. Small flat brush
6. Small squirrel round
7. Mop or large wash brush
8. Round squirrel brush
9. Bristle brush
10. Sponge

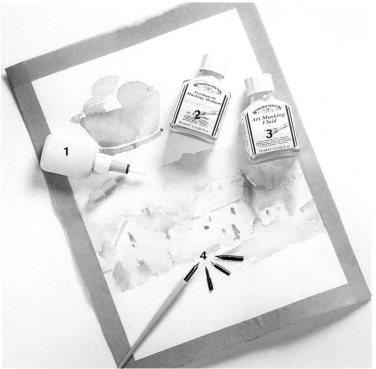

## ▼ PAPERS

Watercolor papers come in three main finishes: rough, hot pressed, and cold pressed.

# Key terms

*Alla prima*—Italian, meaning "first time": when a painting is completed with only one layer of paint applied.

**Analogous or adjacent colors**—Colors that are closely related. For example, blue, blue-green, and green all have the color blue in common. Families of analogous colors include the warm colors (red, orange, and yellow) and the cool colors (green, blue, and violet).

**Aqueous**—Watery, often used to describe media in which water is an ingredient, as in gouache, tempera, and watercolor.

**Binary or secondary colors**—Colors made by mixing two hues, for example, orange (red and yellow), green (blue and yellow), and purple (red and blue).

**Cakes**—Blocks of dry watercolor pigment.

**Cold pressed**—A paper-making process that leaves a particular finish. Cold-pressed (CP)—also called NOT (from NOT hot-pressed)—papers have an open or coarse texture.

**Complementary colors**—Colors that lie opposite one another on the color wheel and have the effect of enhancing each other. Red is the complement of green, and orange of blue.

**Composition**—The arrangement of the subject matter in a way that is harmonious and pleasing to the eye.

**Contour**—A method of drawing where you look exclusively at the model/object without reference to the paper at all.

**Contrast**—The difference in value between light and dark.

**Cool colors**—Colors that contain blue and green, suggest coolness, and are associated with water, sky, and foliage.

**Crop**—To trim a picture's edges.

**Dry brush**—Applying relatively dry paints lightly over a surface, creating an area of broken color where traces of the paper or undercolor remain exposed.

**Filbert**—A flat brush with a rounded point.

**Foreground**—The area of a picture, often at the bottom of a painting, that appears to be closest to the viewer.

**Foreshortening**—A perspective term applied when one is representing an object oblique to one's line of vision.

**Form**—The appearance of the subject matter—its line, contour, and three-dimensionality.

**Gradated wash**—A wash that is light or thin in one area and gradually becomes darker or heavier in another area as more paint is applied.

**Gradation**—A gradual, smooth change from dark to light or from one color to another.

**Highlight**—The area on any surface that reflects the most light.

**Horizon line**—The eye-level line, where water or land meets the sky. Vanishing points are usually located on this line.

**Hue**—Any color as found in its pure state in the spectrum.

**Intermediate or tertiary colors**—Colors produced by mixing unequal amounts of two primary colors. For example, adding more blue to green (the combination of blue and yellow) will produce the intermediate color of blue-green.

**Linear perspective**—A technique of drawing or painting used to create a sense of depth and three dimension. Most simply, the parallel lines of buildings and other objects in a picture converge to a point, making them appear to extend back into space.

**Local color**—The true color hue of an object.

**Masking fluid**—A removable latex gum resist used to protect or reserve selected unpainted areas from wet paint.

**Medium**—The material or technique used by an artist to produce a work of art.

**Negative space**—The space around an object, which can be used as an entity in composition.

**One point perspective**—A form of linear perspective in which all lines appear to meet at a single point on the horizon.

**Opaque**—Something that cannot be seen through; the opposite of transparent.

**Palette**—A flat surface on which to mix paints.

**Perspective**—The graphical representation of distance or three dimensions.

**Picture plane**—The plane occupied by the surface of the picture. When there is any illusion of depth in the picture, the picture plane is similar to a plate of glass behind which pictorial elements are arranged.

**Primary colors**—The colors yellow, red (magenta), and blue (cyan) from which it is possible to mix all the other colors of the spectrum.

**Proportion**—A principle of design referring to the size relationships of elements to the whole and to each other.

**Resists**—Materials that protect a surface from paint in order to maintain paint-free areas of paper. Paper, masking tape, and masking fluid are all resists.

**Sable**—A tense but flexible hair with excellent paint and water holding ability, used for brush bristles.

**Secondary colors**—*See* **Binary colors.**

**Shading**—The means by which a three-dimensional appearance is given to a two-dimensional drawing; the application of light and dark values.

**Sketch**—A quick freehand drawing or painting.

**Splattering**—A method of spraying droplets of paint over a painting with either an old toothbrush or a flat brush.

**Sponging**—Applying paint with a natural sponge to produce a textured surface.

**Texture**—An element of art that refers to the surface quality or "feel" of an object— its smoothness, roughness, softness, etc.

**Tint**—A color to which white or water has been added to dilute the hue. For example, white added to blue makes a lighter blue tint.

**Tone**—The quality of a color, as modified by mixture with white or black.

**Vanishing point**—The point on the imaginary horizontal line representing eye level where extended lines from linear perspective meet.

**Warping**—The wrinkling that occurs to lightweight papers after wetting. The heavier the paper, the less warping occurs.

**Wash**—The act of laying water or pigment on the background or surface of a painting to act as a stain on or through which the details of the painting will show.

**Watercolor**—Any paint that uses water as a medium.

**Wet-into-wet**—Technique in watercolor painting in which a wash is laid on an area still damp from a previous wash.

**Wet-on-dry**—Technique in watercolor painting in which a wash is allowed to dry before more paint is applied.

# 1
# Basic drawing and painting information

This book does not list all the types of brushes you need to have, what type of easel you should use, or which paints to buy. The assumption is either that you already have this information at hand or that you have formulated your own methods by this time.

All artists have their favorite materials, and what suits one artist may not necessarily suit another. What is important is to keep experimenting with the actual business of applying paint to paper. This chapter looks at the use of perspective, balance, and harmony (designing your painting).

In order to progress with watercolor painting, it is essential to address any problems with a view to rectifying them, just as you would if you were learning to be a good gardener. Some of the process is intuitive, but there are certain rules and methods to help you achieve good results.

Watercolor is a versatile medium, and no individual uses it in exactly the same way as another. No one person sees the same things or reproduces them in the same way. So think about how you would like to develop as a painter, use and nurture the natural abilities you have, and add to them in your drawing and painting style. It is quite easy to be inspired by looking at the efforts of other painters, but don't try to copy their style. Look at everything you like about the painting, and analyze why it appeals to you, but do not try to imitate it.

Don't be afraid to paint unusual subjects, images, or interiors, and apply all the same rules to them. Try pencil and wash and pen and wash; try adding other media, such as collage, or additives, such as gum arabic or granulating medium. Above all, keep experimenting and don't give up.

# What do I need to get started and how should I set up my painting area?

Different artists approach a painting in different ways. The challenge with watercolor is that, because of its often uncontrollable nature, it is usually best to plan some of the things you are going to do before you start, even if they are ignored later. Most watercolor paintings progress from light to dark, and so some planning is needed. Areas that you wish to leave white can be protected by the use of masking fluid and so on. Make sure that you give yourself time and think carefully about the finished work. Once your choice of subject, compositional layout, and initial drawing have been decided on, remove any heavy drawing lines with a kneaded eraser.

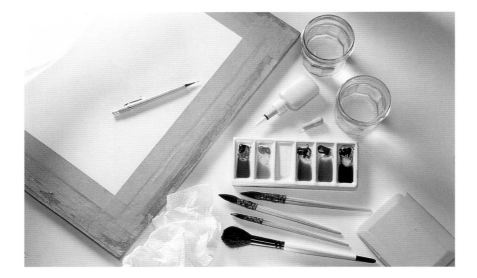

**Left** Make sure you have all the materials you need to start painting. These should include a board with stretched paper, a series of round brushes, a mop brush, a pencil, masking fluid, two pots of clean water, a paper towel, a mixing palette, and paints ready to use.

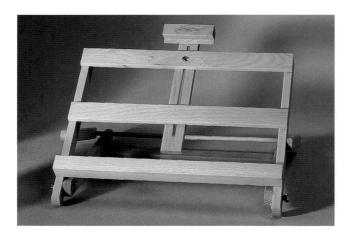

**Above and right** There are many kinds of easels available to rest your drawing boards on, so choose the one best for you. The ones shown here are a table model (above) and a full-size model (right), which can be used outdoors and while standing. Of course, you can always rest the board on your lap or prop it on a table with a book.

**Right** Choose a suitable area to start your painting. It is essential to work in good light, with the light coming from the opposite side of your drawing or painting arm. Having prepared a drawing (if required), sit comfortably in your space or studio. Start your painting by applying thin washes using a light approach. Make sure you have your basic palette colors mixed and in enough quantity for the painting you want to paint.

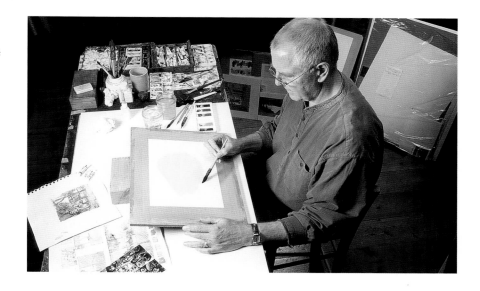

**Left** Once you have applied the lighter washes, follow by applying the heavier, darker washes, along with any details to form the basis of your painting.

### ARTIST'S NOTE

It is a good idea to keep one or two palettes of paint that have been used before and not cleaned out. It is surprising how often the color you need will already have been mixed on a previous occasion.

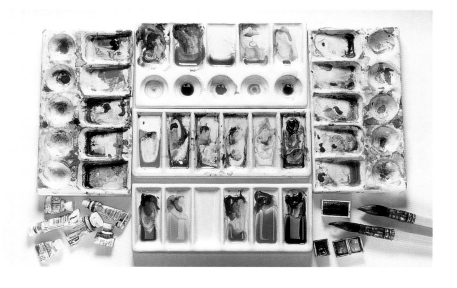

**Right** These palettes contain a number of pure and polluted washes. You may find that you will need more than one palette to achieve all the color mixes needed to complete a painting.

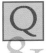

# Q & A

## I have most varieties of watercolor brushes. Which should I use and how should I use them?

It is easy to be overwhelmed by the selection of brushes available. As with watercolor mediums and other aids, try not to get too bogged down with equipment. You can produce good paintings with ordinary watercolor paper, one brush, and just a few colors. Here are three main types of brushes, together with an explanation of the strokes that can be made with them.

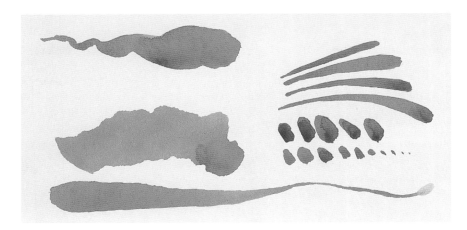

**Round brush (No. 4)**
This round brush will make most marks and washes required. This is an extremely useful and versatile brush, which produces a wide variety of different effects, ranging from wide, rounded strokes to thinner, more delicate strokes.

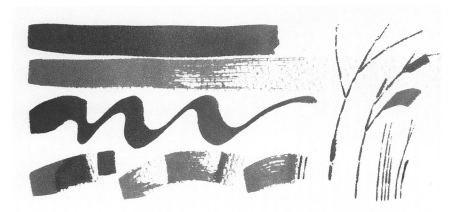

**Flat brush (No. 4)**
Flat brushes are useful for dry-brush techniques, hard-edged lines, and forming repetitive thin lines of the same length where it is important to achieve an even, consistent effect, as would be needed when painting distant features such as tree trunks and fences.

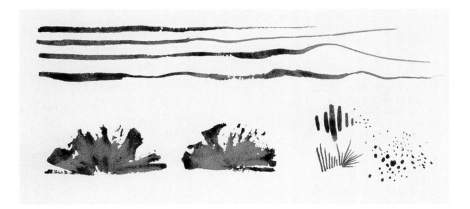

**Rigger**
A rigger is used for forming thin lines, especially for ropes and rigging and reflections in water. This brush produces diminishing lines and interesting shapes when "rolled" on the paper. With a little practice, you will soon learn how to use a rigger effectively.

# Q&A How can I use a brush to vary the intensity of color and tone?

Color and tone are important and merit careful consideration. The visual satisfaction of applying color on white or tinted paper is one of the joys of painting, and various effects can be achieved through differing intensities (tones) of color. These color variations can enhance the mood of a painting; a variation of cool colors can create a calming effect and warmer colors can evoke feelings of energy and vitality.

Sweep a fully loaded brush of color across the page and notice that, as it dries, the edges are a little darker because they have a higher concentration of color settling on the paper. This darker edge may not be desired, but it is an indication of what can be organized on purpose. The variation in tone of a color is where the interest lies and where the painting can be given impact or a change of mood.

> ### ARTIST'S NOTE
>
> Try simple sketches using different intensities of color and color combinations, while also incorporating the information on the division of your painting into thirds (*see* page 21). These experiments should be an enjoyable part of the picture-making process and not a chore to be endured. Some of the most effective watercolor paintings can be completed in less than 30 minutes and appear fresh and vibrant compared with a painting that may have taken several hours.

Try an experiment by applying paint with various small brush strokes, building up the intensity of the color (a stronger mix) as you move across the paper. You could even add a slightly different color to the mix as you go. Now compare this with a simple wash of all the same color and intensity. The color variations and blends will add to the interest in your painting.

# How much initial sketching should I do before painting and how detailed should it be?

**This is very much a matter of preference and style. Some artists draw tightly and paint loosely, and vice versa. Some don't draw at all, instead "drawing" with paint as they go along. Many artists sketch with a soft pencil, leaving a light line that will be covered up by any subsequent layers of watercolor paint. Drawing with charcoal is also possible. Refer to the chapter on *Basic drawing and painting information* on how to design your painting.**

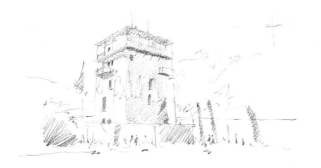

1 Lightly organizing your painting can give you the confidence to proceed with it, knowing that you are at least happy about the overall structure of the work. When painting on location, it is also helpful to have a notebook sketch showing tonal value, shadows, and any other information about a particular outdoor subject that needs to be recorded that will be of use if you are planning to paint later in the studio.

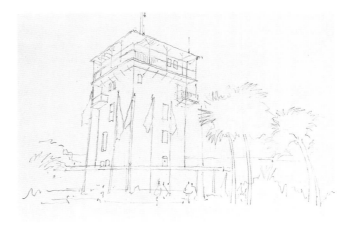

2 Here is a more detailed and considered drawing, prepared from sketchbook notes and ready for painting. The drawing captures the most important elements and forms a solid, effective base to paint on.

3 Don't forget to stand back and analyze your painting at intervals. You will be surprised at the difference between seeing your painting from your sitting position to seeing it on a wall a few feet away, as if hung in a gallery. Initial sketches can give you the confidence that the final image will be successful. Try not to use an eraser during the sketching process because this can affect the fibers in the paper and alter he way in which the water "flows" onto the surface.

4 Sometimes the pencil lines of an original sketch can be deliberately left to show through in parts to create a notebook style, which is very attractive. Sketching over or during a painting can be effective but needs practice, and the crucial factor is knowing when to stop. It is all too easy to overwork a painting, so try to avoid this temptation.

# What is important when painting a still life?

**Here is a chance to create your own set-up to suit your style of painting or to test your skills with arranging and using painting techniques. The crucial element here is composition. Now you have the chance to manipulate the subject, making the best of light sources, background, and color to suit your own preferences, so be careful that the composition you end up with reflects your initial wishes.**

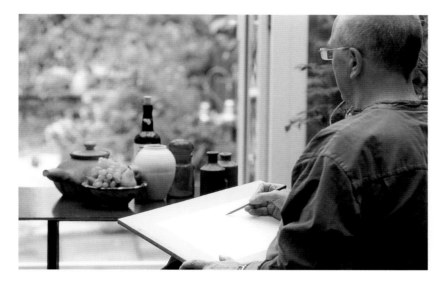

1 When you are setting up your still life, take time to decide on your eye line and point of focus. A very dramatic change in emphasis takes place when the eye line is altered. It is quite common to set up a still life on a table and paint it from an adjoining chair, as pictured here. Although this is perfectly acceptable, try putting the composition on the floor or painting the subject with your eye line level with the table.

2 You can sketch *in situ* (on site) or record the scene by taking a photograph. Either way, try some quick sketches with both a dark and a light background to see the effects that shadows from various positions have on the overall composition. Keep these sketches for reference.

3 Start by putting in light washes to establish the light values. Another tip for creating a successful still life is to use areas of little interest or plain color to set off the main features of the painting. Make sure that the subject is not too central and that some dynamics and tension are created by the juxtaposition of objects and the spaces between them. In this particular instance, a space has been created on the right-hand side of the painting. Also, to counterbalance the handle of the pot, some grapes have been added in this open space. Be particularly aware of the shadows and reflections cast both from the light coming from the window and the reflections of the objects themselves onto each other. Although the subject matter was originally drawn in a conservatory with a garden outside, this has been omitted from the final work. Feel free to change your composition in order to improve the overall image.

# Q & A

## What makes a good focus for a painting, other than traditional subjects?

**Once you are familiar with and confident about various watercolor techniques, look around for subject areas that attract you and that are perhaps more unusual. Out-of-the ordinary subjects often create an atmosphere purely because of their unexpected focus of interest. Try painting the interiors of old buildings or workshops, for instance. In this sketchbook drawing of a group of industrial buildings, the sky has been exaggerated—almost appearing to be on fire—to indicate the industrial process and the city lights in the distance.**

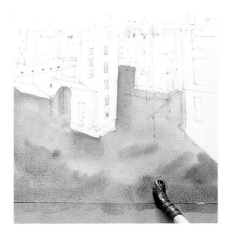

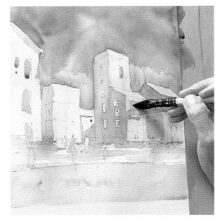

1 Turn your board upside down, and paint in the sky wet on wet using cadmium red and orange. Darken the sky with burnt umber, Payne's gray, or any interesting darks already mixed in your palette. This will secure the roof line of the buildings and will ensure that the sky is at its lightest at rooftop level.

2 Apply a gray-brown wash over the masked-out windows. Add a pink-red wash for a reflection in the foreground wet areas.

3 Complete some redrawing in pencil. (This is a reference sketch, after all, and a form of experimentation and note-taking for use in any future paintings of this type.) Add yellow light (an aureolin and raw sienna mix) to the tower windows and typical industrial glazing bars drawn in pencil.

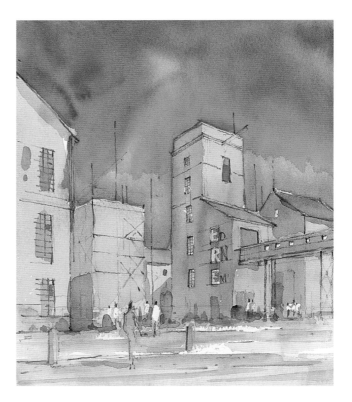

4 This unusual painting was done in a slightly graphic style using an element of draftmanship, architectural drawing techniques, and strong colors. Use all of these examples as a suggestion for alternative ways of expressing yourself in watercolor.

# How can I create a narrative painting and paint my figures so they tell a story?

**Figures in a painting immediately conjure up a story. Figures in a townscape, and the impact they can have on that area of painting, are discussed later in Chapter 6 (*see* page 105). When dealing with narrative painting, the figures need to be the subject of the picture and should contribute to its overall mood.**

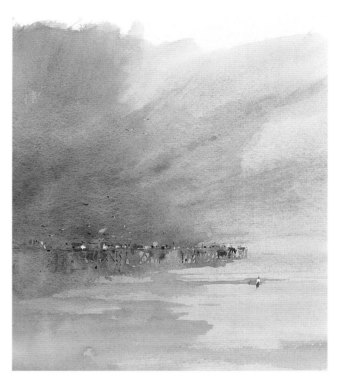

1 A single figure in a painting is a sure way to generate a story. Try sketching your view and placing groups of people or a solitary person in differing positions and notice the change in the story that is conjured up.

2 If you relate the figure to the weather conditions, you will achieve further possibilities for storytelling. Change the attire of the lonely person and the story changes again. Allow the special quality of watercolor to enhance this story, run it through in your mind as you are painting, and allow the story to run down your arm and onto the paper.

**ARTIST'S NOTE**

Everyone has seen a lonely figure walking on a beach or through the countryside. Are they sad or happy? Why is one group of people congregating at the end of a road and no one else is in view? Why are all the people in your scene walking away from you, yet one person is coming toward you? The permutations are endless—just make sure that you think before you paint, and the atmosphere will just arrive. Narrative painting is just as intriguing without people. Think of what may have happened in a scene you are painting, and exaggerate the obvious storyline, even throwing in a few clues.

# How can I frame my painting to greatest effect?

**One of the advantages that watercolorists have over oil painters is that the final size of any painting can be cropped to the most suitable shape, both for framing and for establishing the best arrangement of the painting. Do not be concerned about altering the proportions of your painting to show it to advantage. Similarly, try to paint using the full size of your paper to maximize your possibilities when cropping.**

1 It is a good idea to make the framing of your painting a similar ratio to begin with; then experiment with other sizes to create different effects. Here, some card has been cut to form two L shapes, which can be moved to create different proportions for your painting. This shows a regular landscape (horizontal) shape.

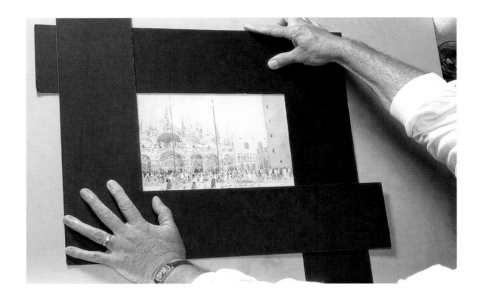

2 By altering the proportions of the framing arrangement, you can enhance certain aspects of your painting. Here, the L-shaped cards have been arranged to show a portrait (vertical) shape. You can experiment with these L shapes until you are happy with the proportions, and then cut your frame accordingly. Your local picture framer will do this when the painting is finished.

### ARTIST'S NOTE

Try to keep your framing as simple as possible; bad framing or the use of unsuitable mats spoils many paintings. A good picture framer will advise you if you are not sure, but remember that, in general, mats should be generous and frames simple.

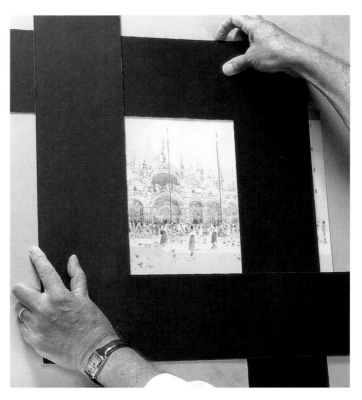

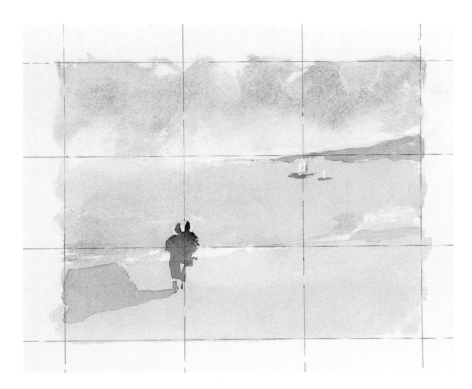

3 It is well known that, when a painting area is divided into thirds both horizontally and vertically, areas of interest or focal points falling approximately on these lines give a sense of balance or harmony to your painting or drawing. This is known as the rule of thirds.

**ARTIST'S NOTE**

When you next visit an art exhibition or gallery, take note of the proportions of the framed paintings, whether landscape or portrait; then, remembering the rule of thirds, see how many fall into the category mentioned. Similarly, take note of any paintings that fail to do this, and decide what impact they have.

4 Having decided on the proportions of your painting, you can finally cut a mat to suit. Once the mat is in place, you will see the final effect of the proportions of your painting more clearly.

# What are the basic rules of perspective?

This is a subject that seems to worry a lot of people, so it is important to put it into context and keep it as simple as possible as far as your watercolor painting is concerned. For a start, you don't have to think about it at all; just draw and paint what you see. However, there are one or two points to consider if you wish to organize your painting properly, as discussed and illustrated here.

## ONE AND TWO-POINT PERSPECTIVE

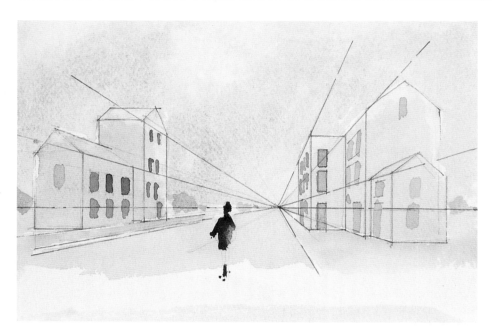

1 Things appear to get smaller the farther away they are. In general, their diminishing lines tend to disappear or converge at a point level to your eye (the horizon line). So everything in your picture (within reason) will reduce in scale until arriving at your eye line, whether the focus of your image is above you, below you, or at eye level.

2 There are three types of perspective: single-point, two-point, and three-point. In single-point perspective, as shown below, all the diminishing lines converge at your eye level at one point (for instance, looking down a single road).

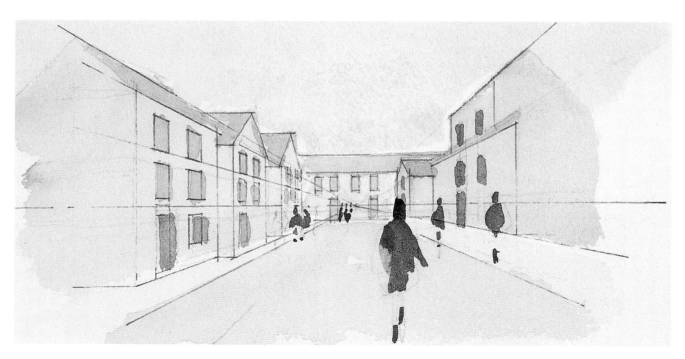

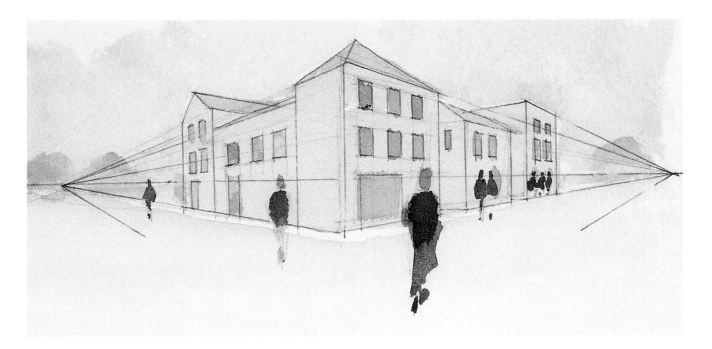

3 With two-point perspective, as shown above, the diminishing
lines from two faces of an image will diminish to two points
on your eye line (as when looking at the corner of a building).

**Left** As the eye-level alters, the lines of
perspective alter accordingly. Any object
drawn above the horizon, or eye-level will
appear as though elevated into the air, the
same object drawn below the horizon will
appear as from a bird's eye view. The
angles of the lines of perspective become
more acute and the point of view moves
further above or below the horizon.

## THREE-POINT PERSPECTIVE

Just as vanishing points finish on the horizon, there is also the phenomenon of disappearance (the convergence of straight lines) above and below the viewer, and therefore there is a vanishing point somewhere above the viewer (in the sky), and one below the viewer (below ground). This is known as three-point perspective, and, added to one- and two-point perspective, would come into play if the viewer were incorporating a view of very high buildings or looking down from a very high point.

Three-point perspective is applicable only if the object in question is still viewable well above or well below the viewer.

**Below** *The Sheldonian, Oxford* by John Newberry
Here the artist has used three-point perspective, but the horizon (eye level) is very low. The angles of the building are more acute, increasing the sense of height.

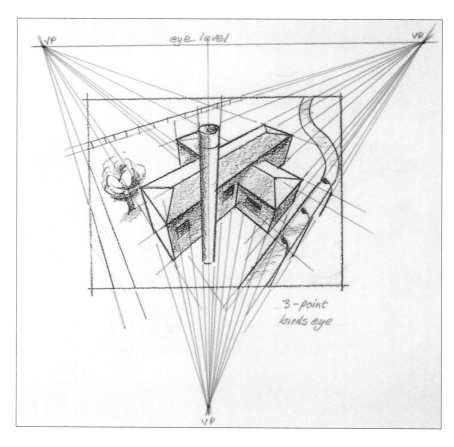

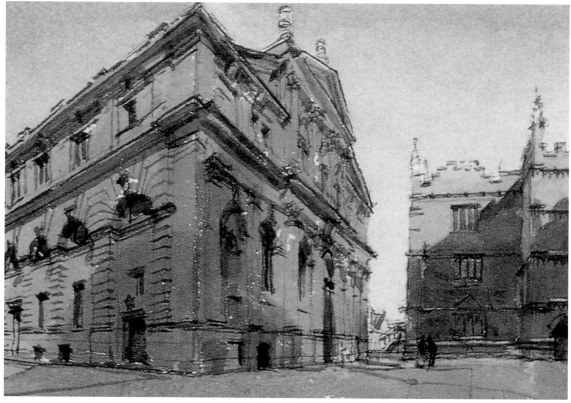

Try to arrange your perspective to enhance your painting and add drama or tension to the subject matter. Remember that a sense of perspective can be achieved simply with color, either by using advancing (warm) or receding (cool) colors or by altering the intensity of color in the background, middle ground, and foreground of your painting.

You can use certain devices to enhance the perception of perspective: diminishing sizes of posts of street lamps, paving slabs, or road markings are all useful markers to enhance the illusion of perspective. Remember that equally spaced vertical diminishing lines appear to reduce in width as they recede.

The window openings at the end of this street are regularly spaced because they are not in perspective, whereas the window openings in the side walls become closer together as the walls recede.

# 2
# Understanding and using color

Because of the spontaneous nature of the medium, color and color mixing is one of the fundamental joys of watercolor painting. When colors blend together on the palette or on paper there is a moment of excitement that is both exhilarating and at the same time sometimes frustrating.

As with all the problem areas in watercolor, what you have to try to do is retain some form of control without the loss of experimentation and all-vital spontaneity.

This chapter looks at color in nature, examines the different effects created by dark and light colors, and also takes a look at the color wheel and the relationship between colors. This background information is important and, if followed, will add a sense of realism to your paintings.

The choice of colors and the interactions between them do not in themselves make a painting. Try to avoid following strict rules about color, and instead experiment a little in order to learn what you need to know. You may find that you often end up with an uninteresting muddy mix; you have to be aware of how to avoid this through experimentation and practice, but do not stop trying out new things with color.

Many great paintings are completed by using only a very limited palette or by sticking to various shades and tones of one color only. Often an artist will settle on a few favorite colors and will seldom want to stray from this palette.

There are many colors and new color mixes available straight from the tube or pan, but use pure colors with restraint as they will overpower your painting.

# The color wheel and complementary colors; what are they?

**The colors that you use in your paintings all have a relationship with one another, and you will notice that some relationships appear harmonious and some do not. These relationships can be used to create different effects in your paintings, but try not to spend all your time theorizing about the colors you are using. Most of the time, the arrangement of color in your painting will come naturally, although some knowledge of color theory can be useful.**

1 The color wheel is just a convenient way of describing basic color theory in a practical way. There are three primary colors: yellow, red, and blue. These are the only colors that cannot be mixed from any other colors.

2 Pairs of primary colors are mixed to make secondary colors: yellow and red make orange, yellow and blue make green, and red and blue make violet.

3 If you set out these colors in the form of a wheel, you can see the relationships more easily. It becomes apparent that the colors opposite one another balance each other out and are what we call *complementary*. Mixing complementary colors creates a range of browns and grays.

4 Red and green and blue and orange are complementary pairings. Look at how these combinations appear in many paintings and also in nature. Consider, for instance, the sense of vibrancy created by the red petals of a poppy against the green of the leaves and stem.

5 On the color wheel, reds and yellows are considered warm colors, and blues and greens are cool colors. It is a fact that cool colors appear to recede while warm colors advance. This can be used to suggest distance in a painting. Colors also have tone (light and dark values).

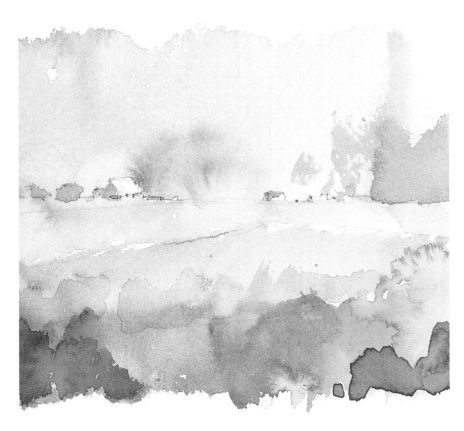

6 The warm colors at the bottom of this rough painting appear to be in front of the cooler colors, further reinforcing the sense of depth of the landscape.

**ARTIST'S NOTE**

There are numerous theories and opinions about color. The important thing is not to become too worried about it; but if you remember these few facts, then your color choices may become more informed. While you are painting, many of the mixes will be created on the paper and some will be accidental. Try to remember what happens to your color mixes, and record when something is successful or when the resultant mix just forms a muddy brown and does not work at all.

# How much water should I use to dilute colors, and how do I best blend colors together?

**For information on color mixes, refer to the color wheel (*see* page 28). But the actual application of watercolor, transferring from brush to paper is a personal thing. Like most watercolor techniques, experiment with it until you find your own personal preference.**

1 Whenever possible, work with a fairly large, fully loaded round brush. Here the brush is being "rolled" in the mix to pick up as much paint as possible.

2 You can blend the colors together in two ways. Either mix your colors in the mixing tray until you are happy, or allow your colors to mix on the paper, wet into wet. The latter is a more unpredictable technique but can be exciting.

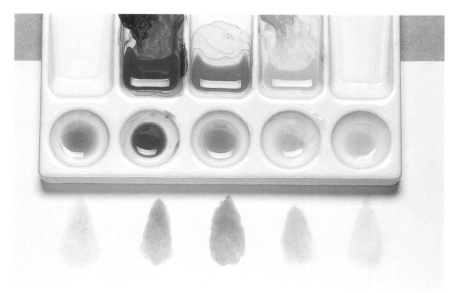

3 Obviously, the more water that is added to a mix or a pure color, the thinner and more transparent that mix will be. You can see here that more water has been added both to the colors and to the mix in the center. The resultant blends of color are shown on the watercolor paper.

4 When you become more confident, you can experiment with heavier mixes in the mixing palette, but be sure to try things out before committing yourself: denser mixes are more difficult to wash out or correct. Here, Payne's gray and permanent magenta have been added in fairly heavy quantities.

**ARTIST'S NOTE**
Remember two things:
too many mixes can usually end up by being
predominantly brown or gray and rather uninteresting;
and colors always dry lighter than they appear when
first applied, so make allowances as you paint.

5 Blue and brown have been mixed together in a fairly strong mix on the paper, having dipped the brush into burnt sienna and French ultramarine straight from the tube in a random fashion. A mix of this kind, when applied directly to the paper with a rotating brush stroke, can create a warm, mixed tone that offsets the unadulterated colors.

6 Do not be afraid to mix any colors without referring to charts or color wheels. Just try them out on some scrap paper—you will be surprised at the possibilities. Here all the warm colors used above have been blended together to form many different warm shades. Try the same thing with cool colors.

# What effects can be created by using localized dashes of color, and how restricted should my palette be?

There are many ways of creating successful effects with color in watercolor painting, and, with luck, many of them will become apparent as you progress. One of the areas where successful results can be achieved is in the considered use of the density—or tone of your favorite colors (*see* also Chapter 3). The use of a restricted palette and the mixing of basic colors to form all the colors used in your painting have already been mentioned, but think about the tone of these colors and how dense or saturated they are.

1 Here is a painting, or, more precisely, a background using a weak wash of some basic palette colors mixed together. This wash forms a neutral backdrop for you to start building up the forms with stronger colors.

2 Applying a more intense version of your basic palette colors over the initial wash, either as pure color or blended as here, will enhance your painting. A more varied palette could overpower the painting.

3 The nature and perhaps greatest aspect of watercolor is its transparent and sometimes even ethereal quality. But using a very strong color in small degrees can generate a focal point and even enhance the more subtle lighter areas. It is, however, important not to overdo the use of localized dashes of strong color.

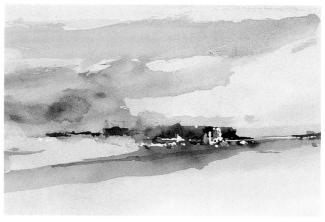

4 Remember that areas of light (or white) detail always become more dramatic when neighboring colors are dark, as is the case here where masking fluid has preserved the white areas. Apply this technique if you want to draw attention to a specific part of your painting.

5 Sometimes you may feel the need to make a correction or "rescue" a painting in some way. In this exaggerated example, Chinese white has been mixed with all the palette colors to show how it is possible to paint light over dark to make such a correction. This technique is not recommended unless you are very confident about the result, so don't be too disappointed if it isn't successful.

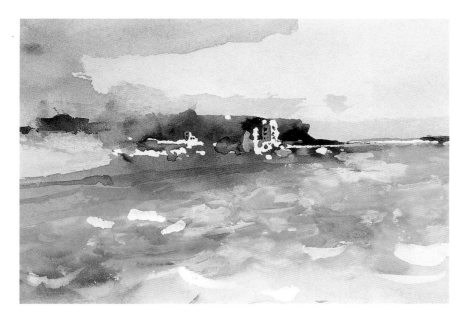

6 Chinese white has been used over the whole foreground just to show how the addition of this opaque color can change the nature of a watercolor painting. The foreground appears more solid than it otherwise would.

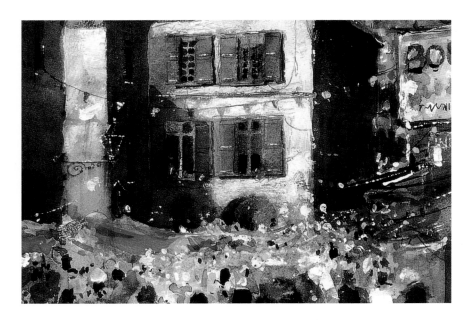

**Adding Chinese white**
In this section of a painting of a market square, you can see what happens when Chinese white is added to the main colors: the painting loses its watercolor feel but gains in vibrancy. It's up to you how far you experiment with mixed media.

What effects can be created by using localized dashes of color, and how restricted should my palette be?

# 3
# Working with watercolor

This chapter deals with the basic business of putting paint on paper. Whether you have just started painting or are a more experienced artist, you will still get a certain pleasure from applying paint to paper, just to see how the colors merge in a random way and form wonderful translucent mixes.

It is important not to lose this excitement because it is one of the reasons for painting in the first place. The problems of controlling the paint will be dealt with as the book progresses, but for now just enjoy the process.

When this book addresses common problems with watercolor, it is assumed that you have made some attempts that have failed for one reason or another. The following solutions should help you use watercolor properly and effectively.

Watercolor is in some ways uncontrollable, and that is what is special about it. Often you try one thing and something else happens, giving a completely different and unexpected effect. Nevertheless, some form of control is needed to ensure that any accidents are happy ones!

A good starting point is to visit local art galleries and study the work of watercolor artists. Notice how many artists use simple, direct, and well-focused strokes to create a simple painting that has real spontaneity, while others will have painstakingly produced every stoke on a field of grass. One of these paintings will have taken one hour to produce, and the other, two or three days. The important thing to consider, however, is do they work? Knowing when to stop is just as important as knowing how to paint.

Paintings are very often more successful when kept as simple as possible. Do not be afraid to leave out elements of your painting that do not add to its overall impact.

To begin with, it is a good idea to paint as quickly as possible. It will help to exercise your mind and concentrate, and the action of the paint on paper will be less predictable and more enjoyable.

Some artists produce excellent paintings in a mere 30 minutes and then feel tempted to work on them further. However, leaving the image overnight, and perhaps trying it with a frame the next day, can highlight the freshness and spontaneity of the picture and reveal that no additional embellishment is necessary.

You may have come to watercolor painting by viewing television programs or videos, by watching someone paint while on vacation, or because you always wish you had continued after leaving school but never had the time.

Whatever your reason, do not be put off by anything. There will always be painters better than you, just as there will be painters who are not as accomplished as you, but that is not the point. Always remember why you started and continue to strive for better results. By all means, be rigorous and disciplined, but always try to take pleasure in your painting.

# Washes—what is it I need to know?

**This is an important question, and it's what watercolor is all about. The most significant and beautiful feature of watercolor painting is what you can do with watercolor washes. A wash is simply an area of color spread across the watercolor paper, usually in a fairly thin consistency. The range of effects that can be produced with a wash is wide and varied, and it can set the mood for the whole painting.**

## AN EVEN WASH

With your board at an angle of about 10 degrees, load your brush with an ample amount of premixed color. Work from the top and from side to side with even, gradual strokes, reloading your brush when necessary with the same mix consistency, making sure that the leading edge of the previous stroke is not allowed to dry.

## A GRADATED WASH

Using a premixed wash, you can repeat the process of creating a wash in the same manner as described for an even wash; but as you progress down the paper, increase the intensity of the color by adding more pure color to the mix. (Make sure you have enough color already prepared and available in tube form in your mixing tray.) Never go back over the wash once it has been painted.

## A VARIED WASH

1 To achieve a mixed color wash, flood the paper with clear water using a large brush and let the paper dry almost completely.

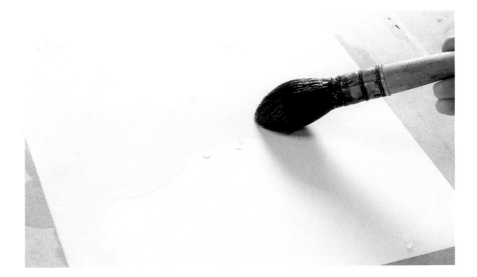

2 Follow with a wash of whatever color paints you prefer, applied randomly but quickly. Colors used here include raw sienna, burnt umber, French ultramarine, alizarin crimson, and permanent rose. Make sure the board is tilted to allow the colors to run into each other.

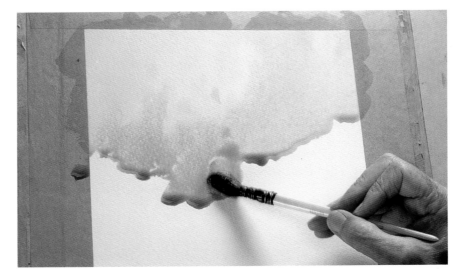

3 Tilt the board from side to side if you wish to let the colors run together. There is an element of risk in this procedure, but very often the result is surprising and nudges you in the direction of the finished painting.

### ARTIST'S NOTE

Keep an example of a trial that turned out to be successful, and note on it what you did so that you do not have to continuously reinvent your techniques. Do not rest on your laurels; keep trying new washes and color combinations.

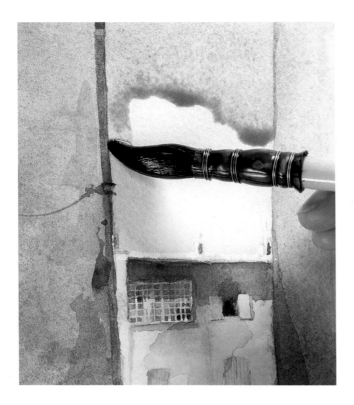

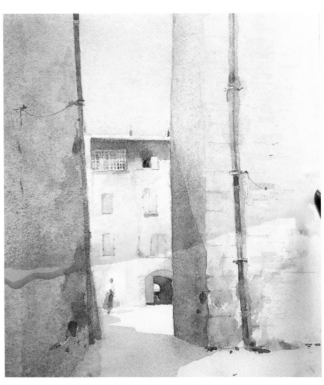

1 Another way of using a wash is to flood the completed or partially completed painting either in whole or in part with a weak color wash. This can be particularly effective on sky or water. It has the effect of "glazing" the painting and unifying the range of colors, often softening the overall feel of the painting. Here, the sky has first been given a light wash with alizarin crimson.

2 Don't be afraid to experiment with overall washes. They can produce interesting results. For example, once dry, apply a very thin wash of raw sienna is applied over the whole painting. Wait for this to dry and notice how a slightly different atmospheric effect has been achieved.

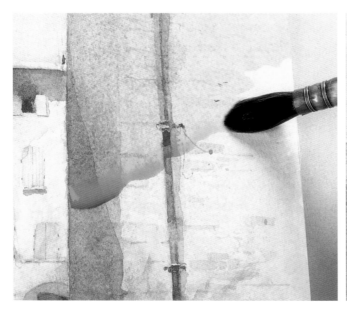

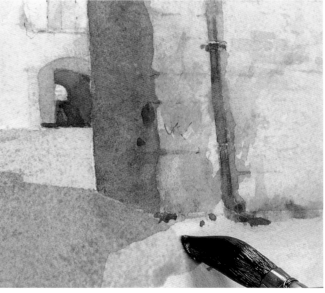

3 Putting a slightly darker wash of raw sienna over the right hand wall brings out its pattern. Let this dry and note the effect achieved and the difference it has made. Then use French ultramarine on the ground to intensify the shadows.

Please note that this method of glazing may not suit your style at all, and you may wish to ignore this technique entirely or only use it in small areas. The main point is to experiment with trial and error.

# Q&A

## Wet-into-wet and wet-on-dry: what do these terms mean?

This subject is a follow-up on the information on washes in that it involves some of the same techniques and approaches. As the term implies, *wet-into-wet* means exactly that; painting one color on the paper and then immediately painting a different color adjacent to it—or even in it—and letting the colors merge to form a third color (or a random mixture of colors and color depths). This is risky, of course, and is difficult to control, but it is what watercolor painting is all about.

*Wet-on-dry* means letting any initial colors dry before adding another color—and not allowing the colors to merge to form a third color. Putting another color on top of an already dry color, however, can alter the original "dry" hue, depending on the colors used and how opaque they are.

### WET-INTO-WET

1 Try using this technique with a bowl of fruit. Lay down a fairly strong wash of one color for the fruit, making sure that you are quite generous with the amount of paint that you use.

2 Before the wash dries on the paper, lay another wash for the bowl, letting the edges touch in two or three places. Notice what happens to the paint: you will have very little control over it! Notice that, although the colors merge, an interesting blending takes place without detracting from either the fruit or the bowl.

1  Try this again, but let the first wash
   almost dry out. Notice that the
spread of the paint is less aggressive
but more likely to form backruns
(blotches of color) and patches.

2  Sometimes the paint does not
   merge when one wash is left to
dry too fully, but this in itself creates
an interesting contrast. Dabs of burnt
sienna and Payne's gray have been added
here to the already wet surface.

3  Now more dashes of Payne's gray
   have been added to the windows,
the fronts of the houses have been painted
in with a light burnt sienna wash followed
by shadows in a darker wash. The
foreground has also been added to
complete the picture. You will need to
paint quickly so that the washes are still
damp and the colors are allowed to merge
slightly at the edges.

## WET-ON-DRY

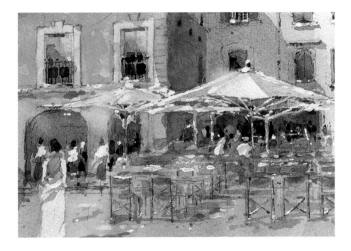 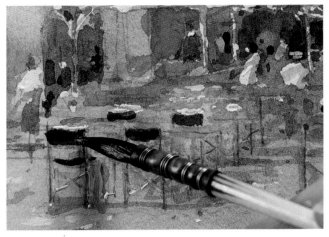

1 Usually, the only way to achieve a successful wet-on-dry technique is to apply a darker or stronger color over a lighter background. As with a lot of watercolor painting, this calls for preplanning and careful consideration of the colors to be used. Totally changing the underlying color with wet on dry paint produces a relatively dense tone (applied in a fairly thick consistency). Here is a painting which is completely dry and could be considered complete. However, the chairs are not distinctive, and so a darker color will be applied.

2 The new color is applied over the old, using the wet-on-dry technique. This color is then allowed to dry, adding greater emphasis to the chairs and creating a more finished look.

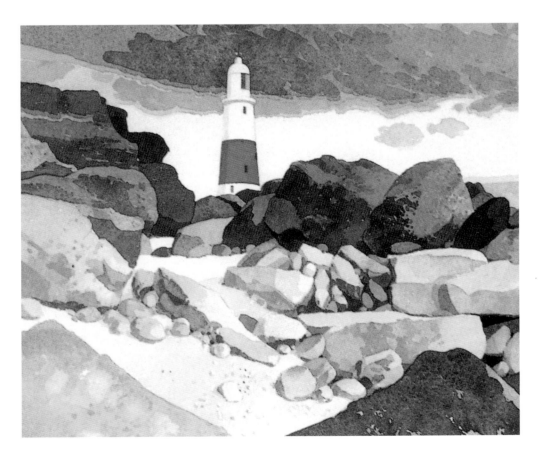

**Left** *Portland Lighthouse* by Ronald Jesty RBA Jesty has worked wet-on-dry, using flat washes of varying sizes to describe the crisp, hard-edged quality of the rocks. He has created texture on some of the foreground surfaces by "drawing" with an upright brush to produce dots and other small marks, and he has cleverly unified the painting by echoing the small cloud shapes in the light patches on the foreground rock.

# How can I convey transparency and opacity?

**Of all the terms used in watercolor painting referring to color or the properties of paint, the one you should be most aware of is *transparency*. Transparency in watercolor painting is achieved by adding as much or as little water as needed to achieve the level of transparency required. Refer to pages 30 and 31.**

1 How transparent a color is depends on how much water is added to it. To a greater or lesser degree, it will determine how much of the underlying color (or color of the paper) will show through or alter the applied color. Here is a thin wash on white paper alongside a thicker wash on the same paper: the only difference is the amount of water used.

2 Here the same thin and thick washes have been applied over an already painted (and dried) color. Note how the underlying yellow shows through the thin blue wash but how the yellow behind the thick blue wash darkens the blue.

3 This example shows a transparent wash alongside the same pink wash with Chinese white added. When a color is not transparent, it is referred to as "opaque." In watercolor painting, it is also often referred to as "body color," which usually means white has been added, eliminating a certain amount of transparency and even allowing you to paint light over dark to some degree. Be very careful, as this process can detract from the translucent appeal of watercolor.

4 On the left, a pink wash has been applied over French ultramarine and left to dry naturally. On the right, the French ultramarine wash was dried with a hair drier before applying the same pink wash: notice the interesting effect this has produced. The pink is lighter; because its drying process was accelerated, the color was not allowed to sink into the surface of the paper.

5 It is a good idea to add a little watercolor to your opaque whites to warm them up or cool them down before adding them to your painting. The warm colors used here are burnt sienna, cadmium red, permanent rose, and the cool colors are French ultramarine, cerulean, and viridian. You can use titanium white, Chinese white, acrylic, or gouache whites, or any water-based paint.

### ARTIST'S NOTE

Watercolors do vary in quality. The best paint is usually known as "artist quality," and it can be expensive but is worth the extra expense. "Student quality" paints are cheaper and fine to use for sketch books or trial paintings. It is advisable to use "artist quality" paints if you can because they are likely to be more permanent.

# Demonstration: Geraniums in a blue pitcher

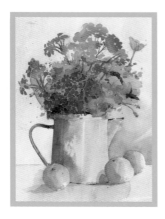

When painting a still life such as this pitcher of geraniums, you have to make a decision about detail and style early on and be confident about your approach. The danger is that you may try to be very accurate about botanical detail, which is good only if you are confident about your technical abilities. But often what is most successful is to give merely an impression of the subject rather than painting each leaf or petal precisely—a lot of detail isn't necessarily good. Make sure that your choice of subject is agreeable to you, or you will not enjoy your painting. Do not be afraid to use interesting items such as bruised fruit or dried flowers.

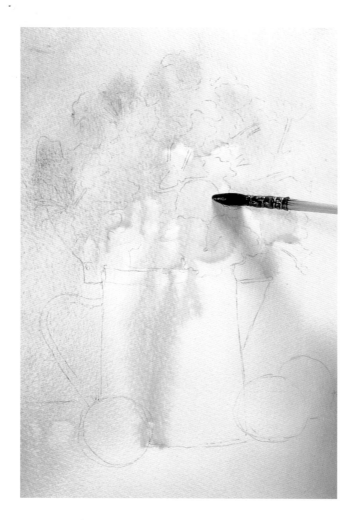

1 First make an assessment of the areas of color in this painting and loosely paint a "ghost wash" of the basic colors approximately in the areas required, allowing the edges to blend together. Here, permanent rose, cadmium red, cadmium yellow pale, and raw sienna have all been used.

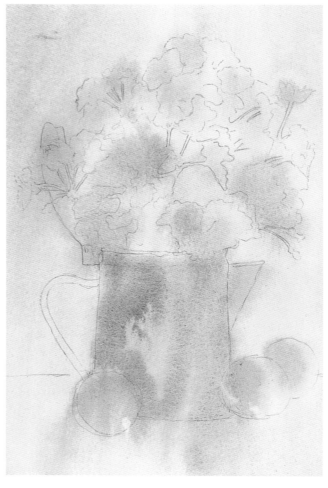

2 Here the outline of the finished painting begins to take shape. See how a basic color map has been set out ready for other colors to be added when dry. You now have a chance to regroup and prepare for the next stage, knowing that your basic background colors are in place.

3 Build up the painting with wet on wet areas of green (Indian yellow and cerulean blue). Allow some red petals to merge with the greens, and paint in other petals in varying shades of reds and pinks. Draw in the stems, and allow some to run into the wet greens. Use a wide brush, and apply your color with care in order to convey the shapes of the geraniums.

4 Reinforce the color of the pitcher, and add color to the oranges. This is once again the process of building up colors in intensity, following on from your basic color scheme and your "ghost" washes.

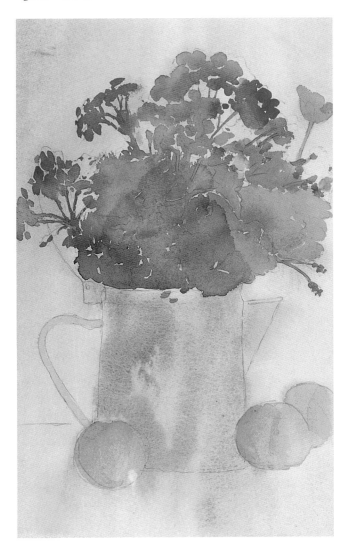

5 Continue to add darker tones to the dry painting, picking out shadows and stems. Keep your image of the finished painting in mind. The shadows will add depth and liveliness to the picture.

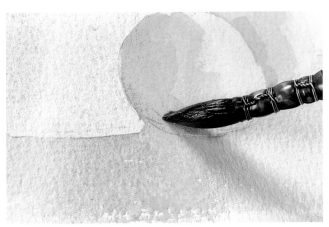

6 Dampen the area of the oranges and the table, and continue to add orange color, allowing it to bleed into the wet table area to indicate reflection. With practice, you will be able to gauge how wet these areas should be and how much paint to add.

7 Further develop the color in the pitcher and handle, and add shadows to the oranges and pitcher using either a mixture of Payne's gray and French ultramarine or a darker version of the base color—whichever you find is most satisfactory. It is important to get the shadows right because they add character. Without them, the painting would look flat and lack dynamism.

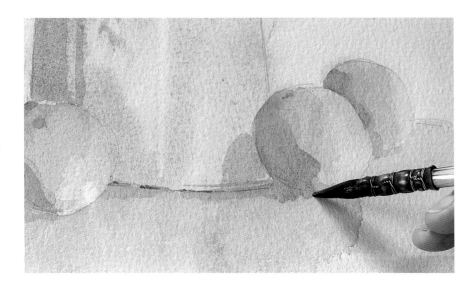

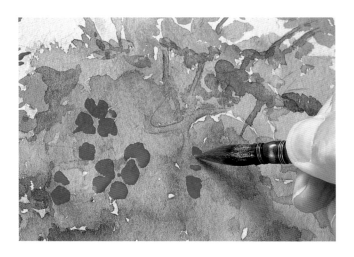

8 When the greens are completely dry, add darker red petals, gradually building up darker colors over the lighter ones. Use a wide brush and keep your brush strokes light and fluid. Avoid any heavy-handedness in working these darker areas of color.

9 Continue to build up color on the oranges, applying the color as heavily as you like and then removing any excess with a paper towel if overdone. Notice how the fruit grows more lifelike and three-dimensional as the orange color deepens.

10 Add further darks to the top of the pitcher where there is the most shadow. This will be the darkest part of the painting, and it should be painted in very small areas with Payne's gray straight from the tube. Be careful to apply it to only very small areas, taking care not to overdo the shadows.

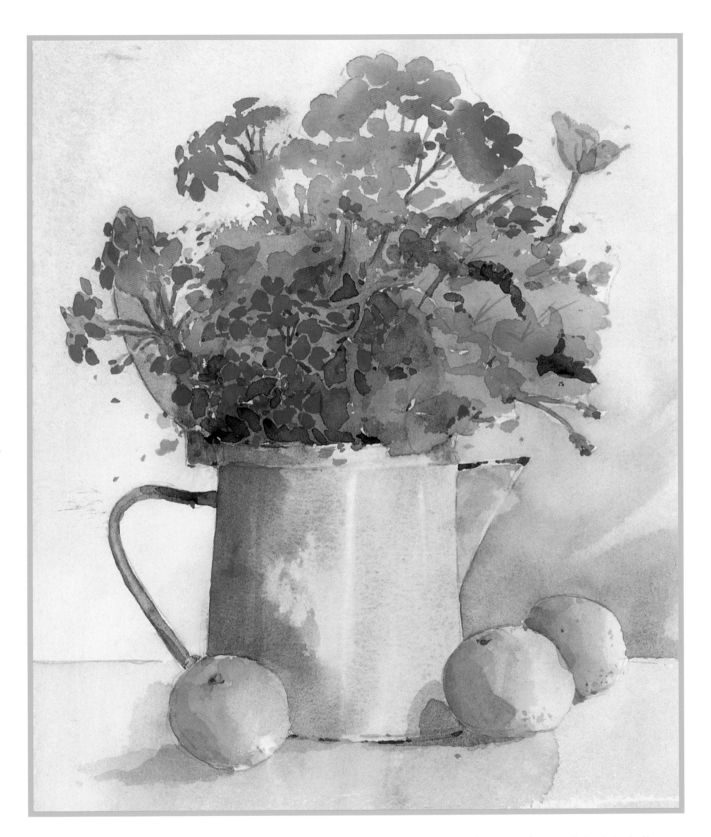

11 This painting demonstrates the relationship between complementary colors. Notice how the reds and greens, and blues and oranges create a sense of crispness. In a painting of this kind, as with many of these demonstrations, it is important to build up your painting, continually adding dots and dashes and small washes of color, layer upon layer, until the desired effect is achieved. The colors here form a balanced and harmonious whole that is very pleasing to the eye. A knowledge of color, and how some colors interact with others, is a useful basis for experimentation in this area. (*See* Chapter 2.)

# I use masking fluid in the recommended way, but when I remove it, my whites look unnatural. Why is this?

**White is an extremely important factor in watercolor painting, whether it is the white of the paper left untouched or applied white paint. Masking fluid is particularly helpful for reserving white areas of paper and allowing the free flow of washes during the painting process. The use of masking fluids must be treated in the same way as the use of paint, however. A common problem is to use too much masking fluid in an attempt to create a dramatic effect. When it is finally removed, seeing the pristine white of the original surface shining through often creates too stark a contrast.**

1 Sketch your drawing and work out which areas you would like to mask. Analyze your subject carefully and only select those areas that will really benefit from masking. These should include areas that are most likely to reflect light, as here, the leading edge of the cup and saucer, or areas in your painting where you envision the lightest highlights. Some preplanning is therefore required before you apply any masking fluid.

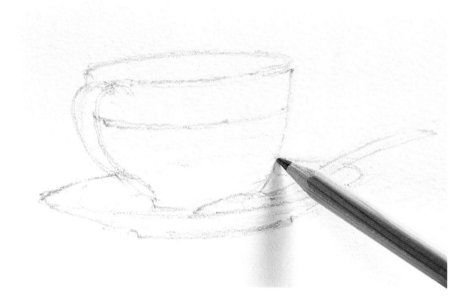

2 After you have completed your drawing, apply the masking fluid in the same way as you paint. That is, if you paint in a loose style, then apply the masking fluid loosely. If your painting is more considered, then apply your masking fluid more precisely. Allow the mask to dry for about five minutes. Never overdo the use of masking fluid as the resulting white areas will look too severe.

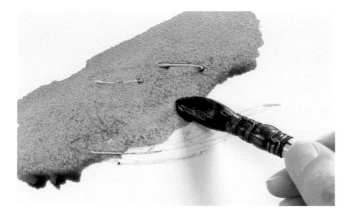

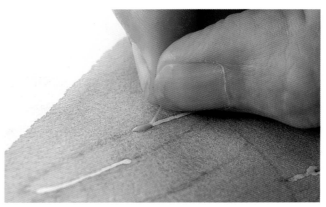

3 If masking fluid is applied in very thin lines (with a crow quill pen), these lines can be left until later in the painting process, when they can be very effective against a darker surface. This technique is particularly effective for painting ropes or wires.

4 After the initial washes have been applied and dried but when the overall surface is still soft, gently remove the masking fluid with your fingers. Further painting may cover some of the white, but it will still read as white in the final analysis.

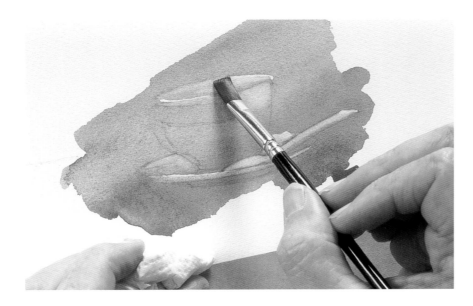

5 Using a flat brush with clear water, blur the edges where the masking fluid has been removed to obliterate the harsh contrast between the white paper and the darker gray of the cup.

### ARTIST'S NOTE

Don't forget that masking fluid can always be removed at any time (either with your finger or with a rubber eraser). It can also be used on already applied color, providing it is dry, to preserve that color in the same way as preserving white paper. You can use a crow quill pen to apply masking fluid but if you are using a paintbrush, clean the brush immediately after use or it will be ruined.

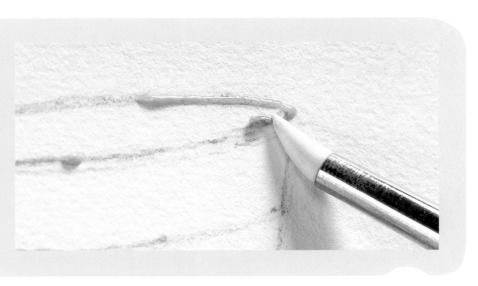

I use masking fluid in the recommended way, but when I remove it, my whites look unnatural. Why is this?

Demonstration: **Lavender fields**

Because of the simplicity of the subject matter, this painting is easy and quick to complete. You need not preplan it in too great a detail. Keep trying paintings of this kind—they can sometimes remind you how important it is to be spontaneous and how even simple paintings can be really effective. This is the kind of painting that can be simplified further, until it becomes a sketchbook painting that you may complete when out walking. Try to complete this style of painting quickly, and then compare it with something that you have labored over for several days. You may be surprised at the comparison!

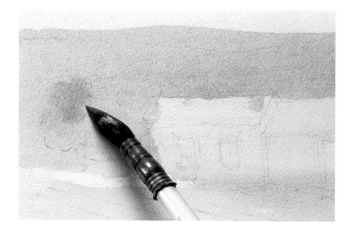

1 Prepare a very quick, loose drawing and apply two dots of masking fluid on one side where the figures will be. Apply the first overall wash of cerulean, adding a little red into the wash at the base so it turns to purple.

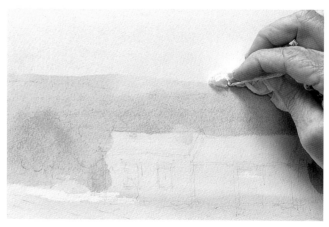

2 When dry, overlay a second wash on the hills, using a large brush and wide, sweeping brush strokes. This now becomes the middle ground of the painting and also begins to create the balance of forms.

3 Using the wet-into-wet technique, paint in the tree while the second wash is still damp, allowing the wet paint to flood into the damp background.

4 Lift off part of the horizon with a paper towel, making a soft edge in places to create clouds and generate interest in the distance.

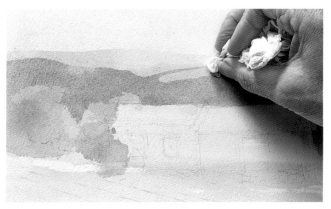

5   Put in a third even darker wash on the hills, creating a sense of perspective through tonal change. You are starting to build up different levels of visual interest.

6   Using a paper towel, lift off further areas to create interest in the hills in the distance. This can be carried out at any stage during the painting, providing the washes are still wet.

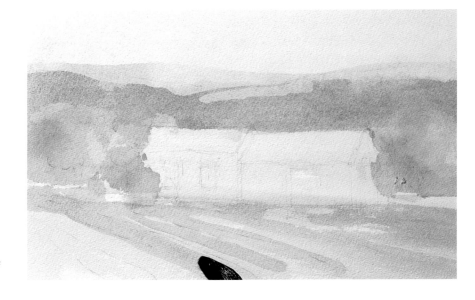

7   Paint in lavender rows in the foreground with quick, simple brush strokes, using your whole arm rather than just your wrist and keeping the brush flat on the paper. Try not to go back over any of your free-flowing marks. Remember the perspective of the scene and respect it.

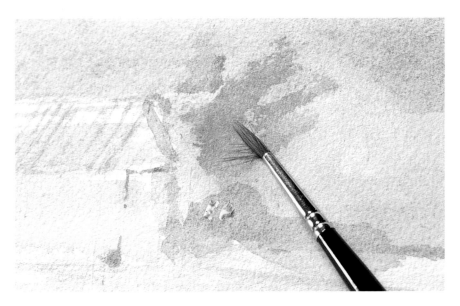

8   With a smaller brush, add darker greens to the tree now that the initial color is dry. Roll the brush against the paper for a slightly broken effect and do not forget to leave gaps in the foliage to allow the sky to show through.

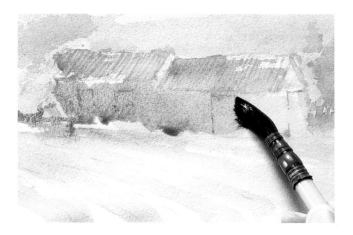

9 Paint the buildings very quickly wet-into-wet, using burnt sienna, Payne's gray, or any wash that you think suitable. Be careful not to be too fussy, and keep all these marks very loose and free.

10 Using a small brush, paint in the windows of the house with a dark mix. Work quickly and loosely. Try to keep these marks as spontaneous as possible, and do not be concerned if some of the colors overlap.

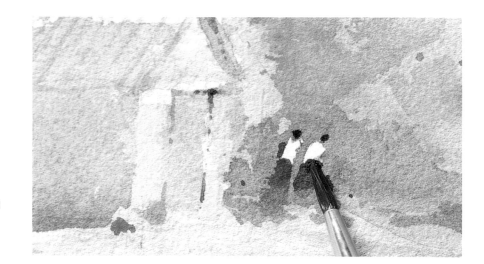

11 Remove the masking fluid dots with your fingers, and loosely paint small figures near the house to add interest to the scene and to balance the painting. Including these figures makes the scene come alive.

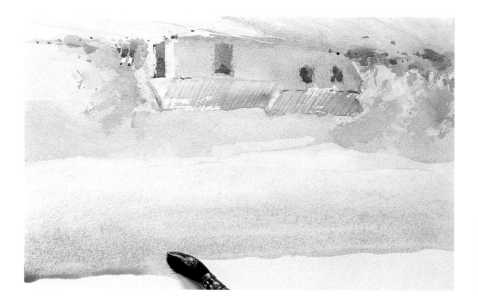

12 Turn the painting upside down and apply a further cerulean wash to the rather weak sky color. This will still keep the lightest part of the sky as the horizon and will create a striking, dramatic effect. Turn the painting the right way up and notice the difference.

13 Lift off some clouds with a paper towel while the wash is still damp. Dab the paper towel lightly to achieve the effect of light, wispy clouds. Make sure you view your painting from a distance to check that the overall balance is right.

14 When the final wash was introduced to the sky area the paper buckled because it was not well stuck at the edge with gummed paper. Because the paper has been stretched, this distortion will dry out or can be removed by using a hair dryer.

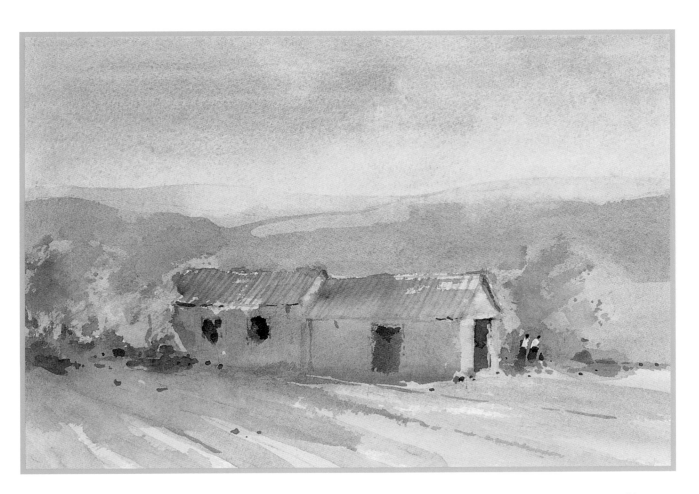

15 This painting was completed in approximately half an hour and benefits from this speed of execution; nothing looks labored. The final image, although very simple and straightforward, appears quite fresh and spontaneous. This illustrates that you do not always need to spend a great deal of time on a painting to achieve an attractive and satisfactory result.

# 4
# Creating atmosphere

Most people would agree that watercolor paintings automatically have a certain atmospheric quality, so you are already halfway there. This is due in large parts to the overlaying of washes and the shining through of previously painted areas. Arguably the best example of this is found in the watercolor paintings of Turner, with which most of us are familiar.

The very fact that water is involved gives the painting a certain "feel;" its fluidity contributes to the establishment of a particular mood. This area of concern is particularly important for watercolor artists, and it is important to get it right.

What invariably draws the viewer's attention to a painting is not how beautiful it is or how well painted it is—although these things are important—but how atmospheric it is.

This is a subjective area, and people (quite rightly) see paintings in different ways. There are, however, certain things you can do to ensure your painting has atmosphere.

This chapter looks at imitating weather conditions, generating movement and creating a narrative painting, among other things. Sometimes atmosphere just arrives; when

it does, be careful not to lose it. Experiment with changing your perceived view of a painting: alter the usual arrangement or color combination, have a dark sky and sunny beach, place a lone person in the middle ground, leave areas unpainted, and purposely smudge or distort elements. All this takes time and practice, but it does free you from the tyranny of painting monotonously similar images.

Detailed drawing and sketching (examined in *Basic drawing and painting information*) can inform the artist of the possibilities of creating atmosphere. Use a soft pencil or charcoal, and try sketching your chosen image quickly and purposefully several times, shading in the sky with heavy, dark lines in one drawing and shading in the foreground in another. Don't forget to use an eraser to "draw" with, streaking across the soft pencil strokes to denote sunrays or vanishing roads.

Always be aware of the unknown viewer. Look at your sketches from a distance as though you were seeing them for the first time. Be patient and be prepared to practice. The transition from sketch to watercolor takes some practice, as well as concentration and time.

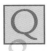

# How can I create a sense of tension and atmosphere in my paintings?

**When painting a picture, you need to consider all areas of your subject matter: composition, colors, shadows, focal point, framing, and just how much of the scene you actually want to include in your painting. As soon as you stray from the conventional rules about balance and harmony, a sense of tension and atmosphere can often be effortlessly achieved.**

1 Here is a large area of foreground, which has a sense of mystery and oppression just as it is because of the unusual ratio of foreground and sky. Had these been of similar proportions, this effect would not have been so easily achieved.

2 Some small detail has been added, which alters the effect. Just a few marks and some pencil darkening create a feeling of distance. A sense of perspective is apparent, but still there is no indication of scale, so the painting maintains an air of mystery.

3 Conversely, here is a disproportionately large area of sky. Because the landscape is devoid of landmarks, it is difficult to establish a sense of scale, and a feeling of vastness and infinity is created.

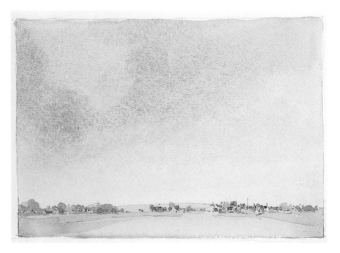

4 A suggestion of some distant buildings and trees has been added in paint and pencil, giving a sense of scale because they are recognizable as buildings.

5 Some clouds have been added with a mix of permanent magenta and Payne's gray applied with just two or three strokes of a dry, stiff bristle brush. A sense of foreboding is immediately apparent.

### ARTIST'S NOTE

Which of these small experiments creates the most successful atmospheric effect? Try these exercises for yourself using your own choice of subject. You may find that the simplest solution is the most successful; if so, do not be tempted to keep adding to it in your final painting.

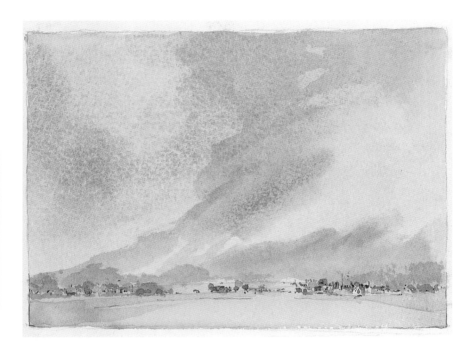

6 Here some rain is suggested by first adding to and wetting the cloud formation; then dragging a dry brush at an angle from the clouds to the land. Notice the shadow of the clouds on the ground.

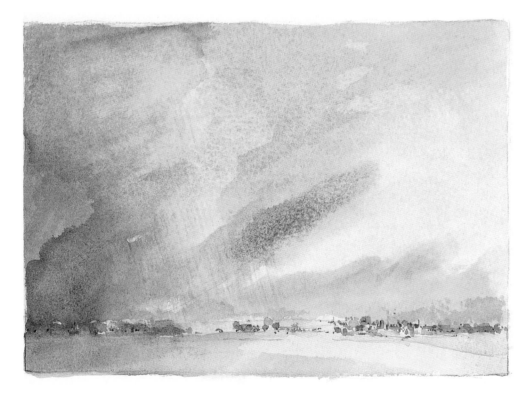

# How can hard or soft edges change the ambience of my paintings?

**One of the most widely used techniques in watercolor painting is the creation of subtle changes in the edge between one color and another. A hazy effect can be achieved by breaking up the edge of such a meeting between two colors. The distinction between land and sky in a watercolor landscape is a typical example. Depending on the light conditions or time of day, the land/sky horizon may be very distinctive or very blurred. An interesting effect can also be achieved by combining these two examples, as the demonstrations below illustrate.**

1 Paint the sky and allow it to dry almost completely; then paint the land up to the skyline and allow the two to bleed together slightly. (You will become experienced at recognizing the right moment when to execute these techniques.) While the paint is still damp, use a paper towel or sponge to wipe away, and therefore soften, the line forming the separation between land and sky.

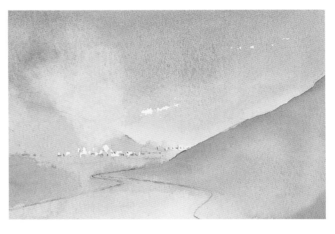

2 The left-hand side of the painting is softened where sky and land meet, creating a sense of distance. On the right-hand side, the line between land and sky has been left as "hard" suggesting nearness.

3 Try painting the sky and the land areas, allowing the two washes to meet and merge at specific points only. The colors will merge at these points and provide a random soft edge.

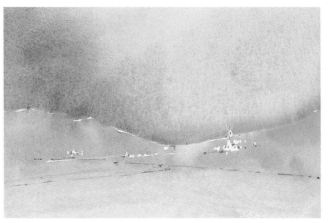

4 Notice that in this example, the random soft edges have created an impression of haziness. Had the edges been hard, a sense of crispness would have been achieved.

# My dark colors look lifeless. I want to use black in my shadows, but they always look heavy and dead. What should I do?

**The secret here is not to use pure black at all. Many painters avoid using black altogether; much more successful results are achieved with a color or mix that is nearly black, or very dark blue or brown, especially when used over large areas.**

1 One of the important things in watercolor painting is building up dark areas with successive layers of paint, sometimes using dark paint as a final coating. The trouble with this method is that it is usually achieved by applying layers of paint wet on dry (*see* page 41) and the result can be as dead or as flat as if you had used black.

2 To avoid this dullness, try to vary your dark colors as you apply them wet on wet (*see* pages 39–40) to give the dark area some variation, even if very subtle and almost unnoticeable. The final result will be more likely to have some life. Try also to make sure that some of the mixes for the dark colors are used in other areas of the painting in order to balance the darks against the lights. This is true also of the use of all colors in your paintings.

### ARTIST'S NOTE

Don't forget that you are painting in watercolor, so the contrasts you will achieve between light and dark areas are not as pronounced as they would be if you were using oils. Do not try to create the effect of an oil painting with watercolor. The beauty of the medium lies in the subtlety of tones and atmospheres that can be created. By all means, make your darks as dark as you wish, but they do not have to be any darker than required to emphasize the light areas. Restrict the use of black to very small "dashes" or "dots" in dark areas, just as you would restrict the use of pure white.

# How can I best convey weather conditions and plan where to place the light and shadows?

When you are attracted to a particular scene, what is it that has caught your eye? Is it a beautiful panoramic view or perhaps an interesting juxtaposition of buildings? In most cases, it is the play of light—and in particular sunlight—on a chosen scene that gives it its special interest. It is a good idea to use a viewfinder, or cardboard frame, to focus your eye on the scene. While you are framing the scene, look carefully at how the shadows fall and what they indicate, such as the time of day, how much of your painting will be in the shade, and so on.

1 The sky—or lack of it—and the positioning of your foreground can alter the atmospheric effect of your painting. Look at the two examples above and gauge your response to both. What is the difference between these very simple examples? If you cover one and then the other, do you get a different reaction? Is the weather suggested here?

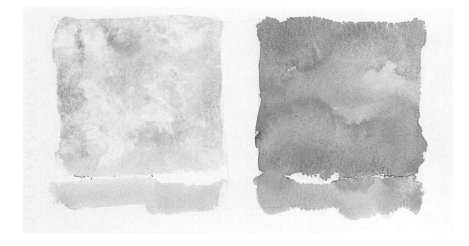

2 If you have a big sky taking up the majority of your painting, you can generate a feeling of light with a clear sky. Conversely, if the large area of sky is heavy with menacing clouds, then a feeling of foreboding is achieved.

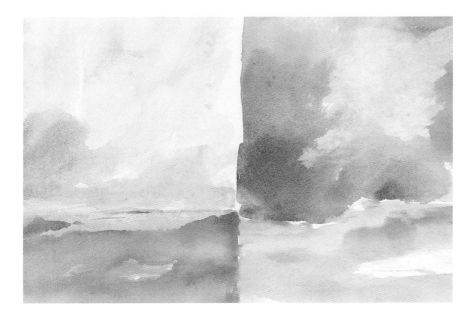

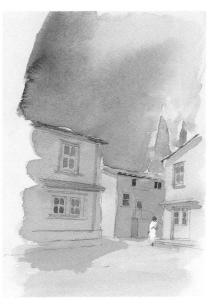

3 Think about opposites. Again, the element of surprise is a great focus for atmosphere. Try a clear blue sky with a dark middle or foreground, or a dark sky with a light foreground, and a storm may be imagined.

4 Try showing shadows, but suggest distant sun through the clouds in a dark threatening sky.

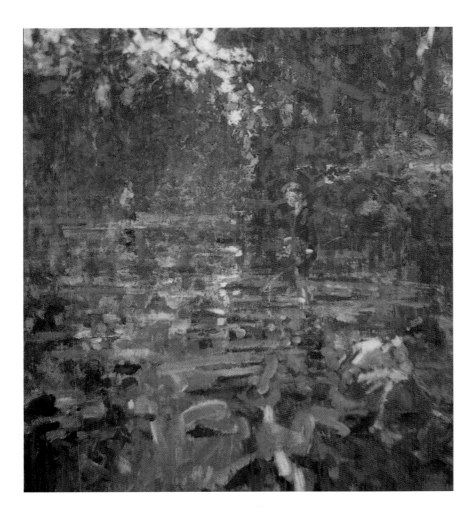

**Left** *Towards Fresh Woods*
by Arthur Maderson
The warmth at the end of a hot summer's day is conveyed in this painting because the sky appears white, bleached of all color by the power of the light. The shadowy creek is painted with shimmering blues and complements the warm yellow sunlight glimpsed behind the trees.

How can I best convey weather conditions and plan where to place the light and shadows?    **61**

# How can I create the effect of smoke or mist?

**This is an interesting area of concern and comes under the general heading of special effects, many of which you will develop for yourself over the years you spend painting. Painting wet into wet is one of the most important techniques in watercolor painting, and this is the technique used to achieve the look of either smoke or mist.**

## SMOKE

2 Turn your board right side up when the wash is nearly dry, and perhaps lift off or wipe off some of the paint in an upward movement.

1 Smoke can be a very seductive focal point in a painting and should be treated sparingly. Once you have applied your base wash, turn your board upside down and allow a blue-gray or yellow-gray wash to dribble from the land through the sky, increasing in width as it advances, if possible. Do this while the sky is damp, and don't be afraid to wiggle your board in order to create a more interesting smoke pattern. If necessary, add clear water to the dribbling smoke.

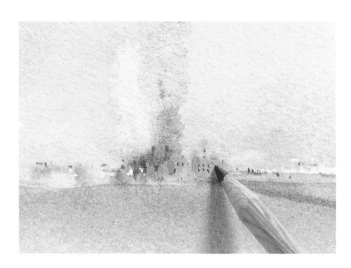

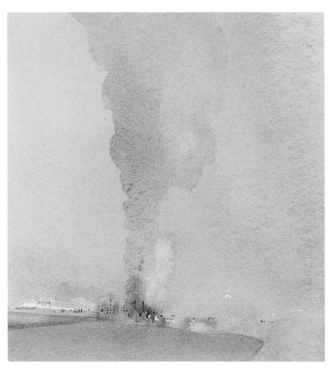

3 When your painting is dry, strengthen some of the details in buildings and other areas of interest with either paint or a pencil.

4 Here, the final image gives an indication of smoke in the distance. The smoke could be coming from buildings or a factory. You could easily intensify the smoke by wetting the paper and adding more darks, but try to achieve your final color when applying the first washes.

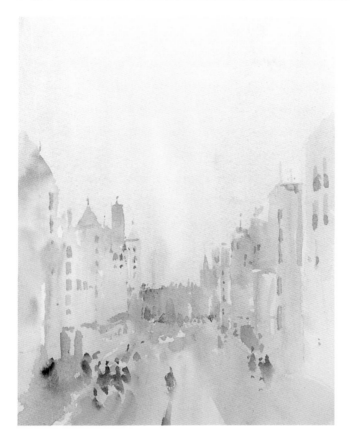

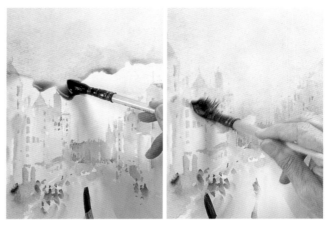

2 To add to the overall effect, apply a weak wash across the whole page. Use a clean, wet paintbrush to "rub out" some of the background, or remove some of the wash in appropriate areas with a paper towel or a sponge.

1 To create a misty effect, make sure the colors you use for your painting are weaker than usual. Colors that are too heavy will appear too flat, and you will not be able to convey the ethereal quality of the mist.

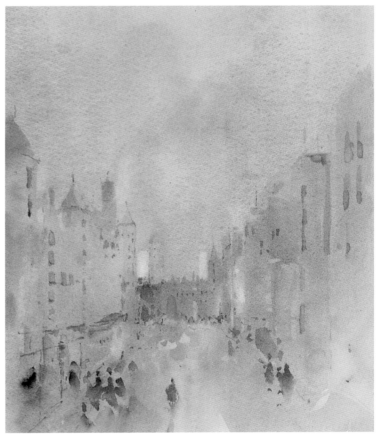

3 Finish by highlighting any small areas that have escaped the mist. The wash will hopefully bleed into some of the figures, making them slightly more indistinct and blurred. Remember to keep everything in the painting as fluid as possible: nothing should be too clearly defined, or you will lose the mystery of the scene.

4 In the final image, the mist dominates the overall scene. Try making only the background misty and keeping the foreground clear by using the wet on wet technique for the sky and buildings at the end of the street only.

# Demonstration: The bridge at Brantôme

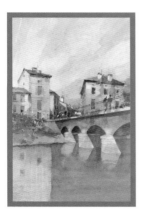

As a watercolorist, you will always be on the lookout for painting subjects. This view is taken from the beautiful French village of Brantôme in Dordogne. It captures certain elements that are important in drawing and painting such as the proportions, that work well, and the perspective of the bridge which leads your eye to the focal point that is the street between the two buildings, and beyond, leaving your imagination to create a more complete picture— what lies past the buildings in the town center. Other areas of interest include the passers-by walking along the bridge, the reflections cast in the water, and the shadows against the buildings.

2  Apply masking fluid with an applicator to the areas to be retained as white, in particular on the distant walls in the sun. Take your time and keep as steady a hand as possible.

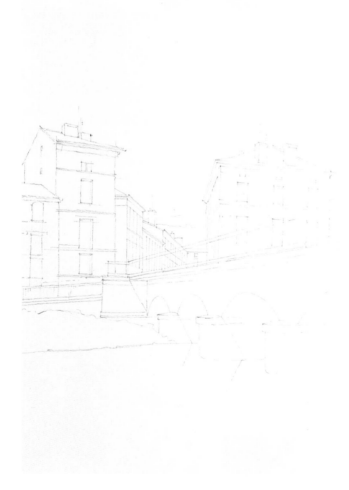

1  Sketch your drawing in pencil so that you have a clear idea of what you'll be painting. Sketch on site or use a photograph as a backup. Lightly draw in the outline to indicate significant areas. You can always rub out any excess pencil with a kneaded eraser.

3  Add an overall wash to the sky and all of the foreground, using a mix of French ultramarine, raw sienna, and burnt sienna in order to redraw the picture with a "ghost wash." Remove the darkest pencil lines with a kneaded eraser.

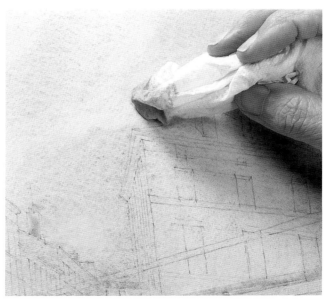

4 Allow the wash to permeate the whole painting, and be sure to keep all the edges of your wash wet so that you do not get any obvious delineations. The blue wash creates a summer feel and anticipates the final result.

5 Lift off parts of your wet sky either by dabbing or "rolling" a paper towel on the surface. Paper towel will produce natural-looking clouds, and the effect will not be too heavy.

6 The painting is now set with appropriate colors that act as a background to any further washes and details.

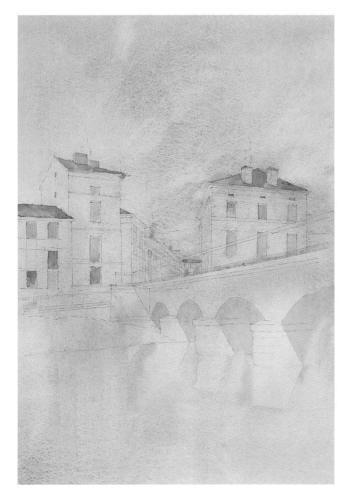

7 Peel off the masking fluid with your fingers, as shown here, or by rubbing with your fingers if a large area has been covered. These areas will remain white in the finished painting.

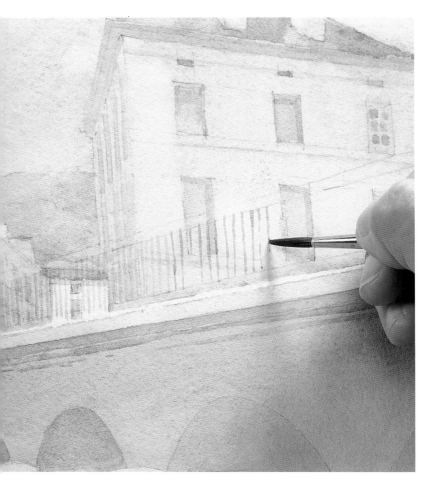

8 Add details such as the balustrading. Make sure that your verticals diminish in width as they recede, creating a sense of perspective. With a steady hand, use a fine brush, and be sure that all your strokes are absolutely vertical.

9 Paint the shadows on the buildings and the bridge with a mixture of Payne's gray and ultramarine, using a smaller brush for difficult areas. (Note that it is always advantageous to show diagonal shadows to emphasize the direction of sunlight.)

10 Use a small brush in the finer shadow areas. Make sure that your brush is well loaded with paint, but paint in any shadows with care.

11 Continue painting the shadows on the bridge, once again using a small round brush to work into the difficult areas. Take your time and work carefully. You do not want to spoil the effect by making a mistake by rushing.

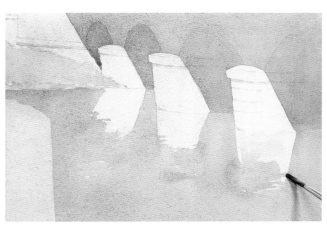

12 Make sure the shadows from the bridge continue into the water, this time using a larger brush and a lighter, more watered-down shade of gray.

13 Take care that no hard edges are formed by the shadows in the water, and paint in some ripples with a small round brush. Delicate brush strokes are best here.

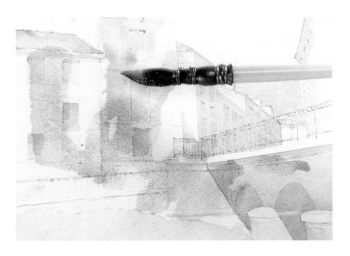

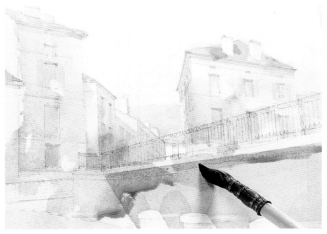

14 Reinforce the wall color with raw sienna with a rolling-brush technique, laying the brush down parallel to the paper and "rolling" it across the surface.

15 Now do the same with the bridge color, using burnt sienna and the same rolling-brush technique. Do not be afraid to use reasonably strong mixes of color.

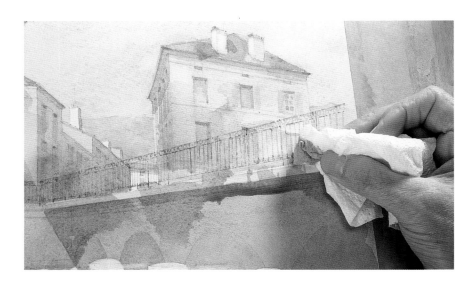

16 Wipe off any areas of excess paint with a paper towel. You do not want to swamp your painting in paint.

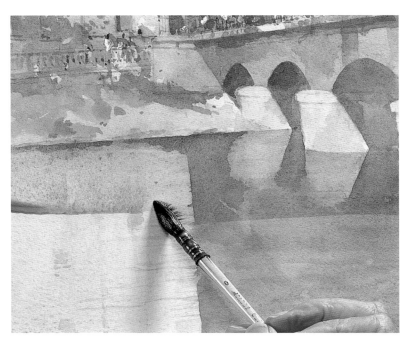

17 Use a flat brush dipped in clean water to form disturbances in the shadow ripples in the water. This adds to the realism of the scene and gives it movement.

18 With sweeping, wide brush strokes, add an overall French ultramarine wash to the river to reinforce the water area and unify all the reflections. This will help make the water seem glasslike and less fragmented.

19 Put in figures on the bridge and in the distance, again to give a sense of perspective and scale. Add interest by applying strokes of cadmium red and Chinese white straight from the tube. Add trees and other marks such as antennae in pencil.

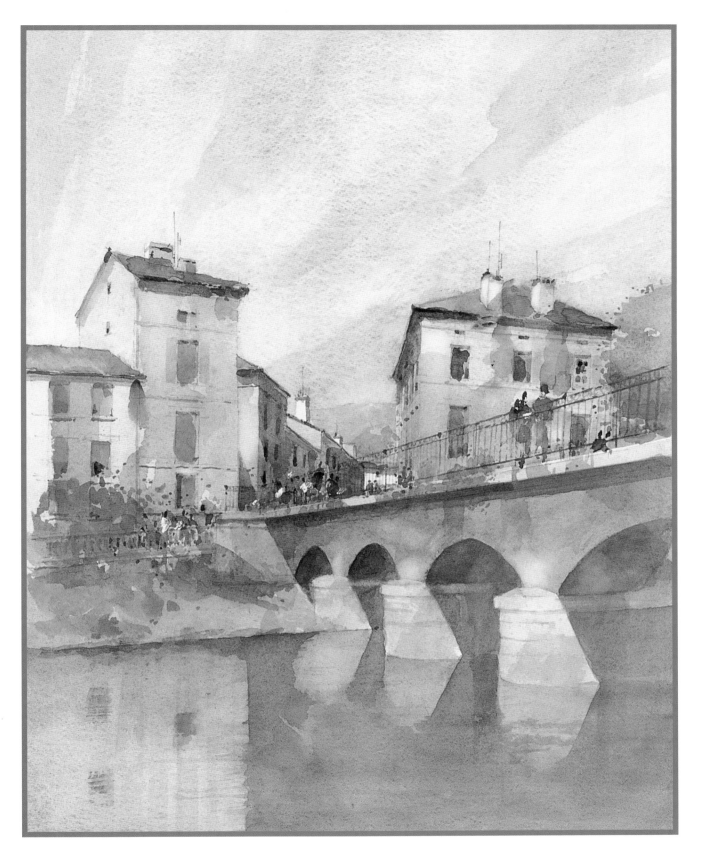

20 The finished painting is balanced, well-structured, and lifelike, with a good contrast between light and shadow. Notice that the perspective leads you into the main focus of the painting: the people at the end of the bridge. Remember these things when you are selecting your watercolor subject.

# My watercolors are rather tight and seem overworked. How can I achieve a looser and more broken effect?

**Take another look at the paper you are using. When you start to use watercolors, you may have been given some paper and paint and never experimented with anything different. This also applies to the application of the paint itself: you may be restricting the possibilities you have of creating a new "style" by a lack of experimentation with brush strokes.**

1 There are many watercolor papers, but the three main types are rough, "not" (cold pressed), and hot pressed. These papers are generally made in three weights: 190 gsm (90 lb), 300 gsm (140 lb), and 640 gsm (300 lb). For best results, you will need to stretch your paper.

2 Watercolor paper needs stretching before applying any paint to it or it will buckle. To stretch your paper, immerse it in a bath of cold water for 10 to 12 minutes, making sure that the paper is completely soaked. Remove by holding the paper in one corner so that all the excess water runs off. Lay the paper on your board, making sure there are no trapped air bubbles or wrinkles in the paper.

3 With a folded paper towel, lightly wipe the edge of the damp paper along each side (where the gummed tape is to be applied). Handle the paper carefully as you do this.

4 Dampen precut strips of gummed tape. The tape should be wide enough to cover the edge of the paper and also give good adhesion to the board. A 2-inch- (5-cm-) wide tape is a good choice.

5 Starting with the longest edges, place half the damp tape on the paper and half on the board; then press down with a paper towel. Leave the stretched paper to dry, preferably overnight, laid flat in a normal room temperature.

6 For a broken effect, try experimenting with a "rough" paper and a well-loaded paintbrush. Notice that the paint settles in the "valleys" and leaves the "hills" paler when the brush is drawn slowly across the paper.

7 To achieve an even more broken effect, move the paintbrush quickly across the paper. You will notice that the color deposits on the hills of the paper and the valleys are left paler as the paint does not have time to settle in them.

8 A very effective paper to use for a certain type of loose painting is a hot pressed paper. Here the paint slides on and gives a totally different result than textured papers do. The effect achieved is smooth and even.

My watercolors are rather tight and seem overworked. How can I achieve a looser and more broken effect?

# How can I generate a sense of movement in my paintings?

**The illusion of movement within a painting is very exciting and deeply rewarding when successful, as the atmosphere becomes agitated and lively. As with a lot of watercolor work, the technique here is to use both wet on wet and wet on dry; here we use wet on wet initially, using very bold sweeps of color with a flat brush and allowing the colors to mix on the paper. You must be bold and take risks if you want to achieve an exciting feeling of movement. You may have many attempts and only one success, but it will be worth it.**

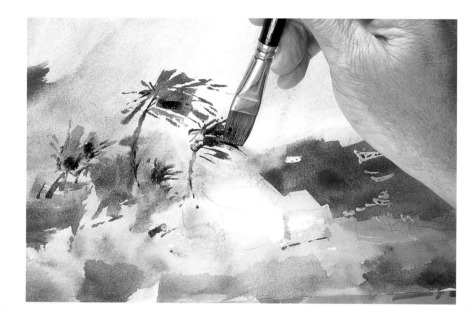

1 Apply masking fluid where required, making sure that you apply it in the same manner as you apply paint. Using a flat brush, make bold and decisive marks to create the disturbed mood of the painting. Use the edge of the flat brush to mark out the shapes of the trees, making sure that the emphasis is in one direction: the direction of the wind.

2 Next, delineate the areas where there is no movement in a more considered way, being careful not to encroach on already established shapes with any hard lines. Not everything in the painting moves, and the still areas will contrast with the areas of movement and further emphasize the dynamism of the scene.

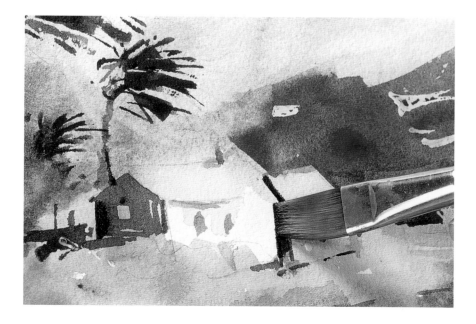

3 Don't be afraid to wet your painting and scrub with a stiff oil painting brush to remove areas of paint and blend in with background colors. This in itself can create a sense of movement. These techniques will become second nature to you in time. Keep practicing until you are satisfied that you can convey movement successfully.

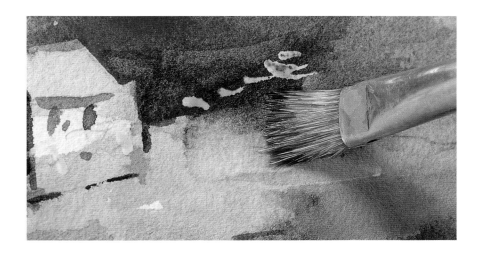

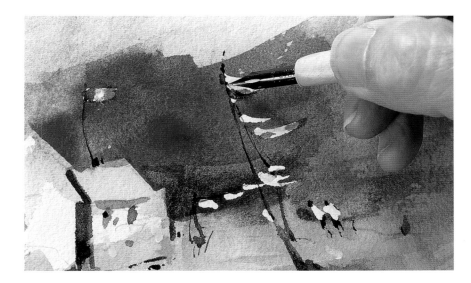

4 Rub off the masking fluid with your finger. Accentuate anything affected by the wind, and exaggerate the directional movement on the clothesline and flagpole using a crow quill pen. Note how the small detail of the laundry flapping in the wind adds impact to the scene.

5 This final image shows an exaggerated indication of movement and a different and more colorful style of painting. Don't be afraid to keep trying new things and influences from other painters—providing you eventually settle on your own style.

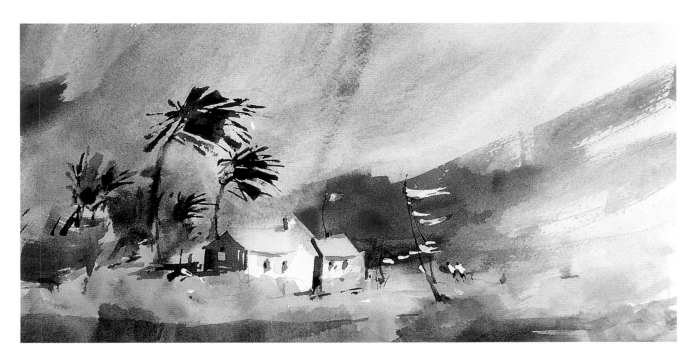

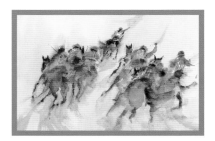

Drawing horses—and drawing animals in general—can be challenging, and once again it is important to make a bold decision to try to paint what you see as best you can. The atmosphere here is hot and intense, so this should be reflected in the colors you use and in the way you paint. Imagine the heat, the sweat, and the dust as you paint. This is very much a wet into wet painting, particularly in the early stages when the atmosphere is being created, so be prepared to complete most of the painting in one fairly quick session before you let it dry.

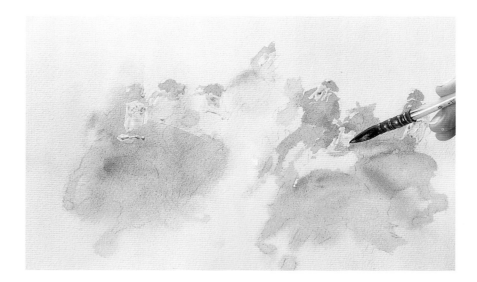

1 Prepare your drawing. Mask off areas with masking fluid such as shirts, caps, etc., and paint an overall wash of raw sienna. While this is still damp, add more burnt sienna to the horses and allow the colors to merge together, making sure that they fade and become indistinct at the bottom where the horses' hooves are disturbing the dusty track.

2 Go back over some of this initial wash and bring in more color using burnt sienna, raw sienna, or even a mix of both colors.

3 At this stage, the painting is still damp, with very indistinct but recognizable characteristics. Despite the looseness of the painting, it still manages to convey the true atmosphere of the scene.

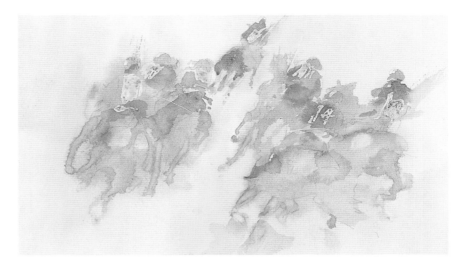

4 As the paint dries, more detail is required. Add touches of burnt umber to the horses' heads and legs and to define shapes. Here the scene starts to come alive and sense of movement is conveyed.

5 Paint in the horses' tails with one flourish, making sure that your painting stroke starts with heavy pressure and finishes with light pressure to enhance movement. Use your arm, not your wrist, to execute the action.

6 Rub out the masking fluid with your fingers, and apply more color and detail, making sure you pick out the areas that will eventually be the darkest in the painting for the first application of color.

7 Use a crow quill pen for fine lines and other details. Add dots and dashes where grit and dust may be flying.

8 Use a flat brush with clean water or a stiff oil painting brush to "scrub" away paint in areas around the horses' hooves to generate a sense of movement, blurring the image at this point. It is the fluidity of the image that generates the feeling of movement.

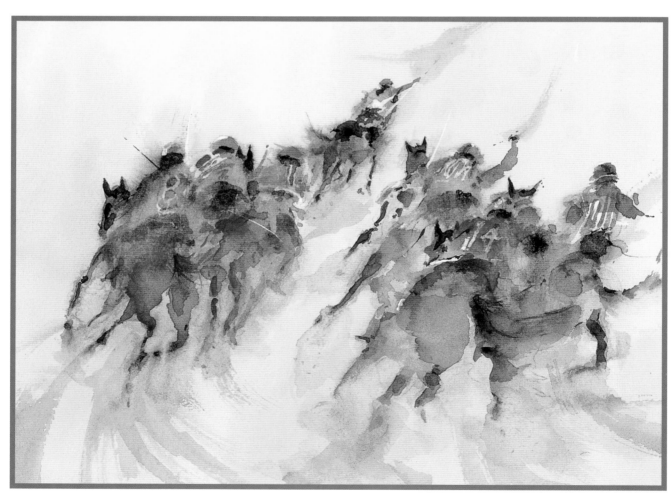

9 Practice your brush strokes with wet-into-wet and scrubbing techniques to finally generate the movement and atmosphere you desire. Use a spray bottle to lightly dampen the paper at any stage of the painting if you find the paper becomes to dry. The applied colors may then even run together a little if the board is tilted and moved in different directions.

**Above** *Dog with a Stick III* by Lucy Willis
Painting rapidly without waiting for washes to dry allowed some brush strokes to run together, giving a sense of blurred movement. This is offset by crisp brushwork on the muzzle and front paws to clearly define the forms.

# 5
# Developing a landscape

Landscape painting is generally something seen in a "broad view"—that is, a vista that encompasses as much as possible and as far as the eye can see.

Landscapes are probably the most popular watercolor subjects, and although a landscape can include elements such as buildings and water, the overall scene is of the essence. When embarking on your landscape painting, remember that the important thing is the view itself, not the individual smaller elements that make up that view. (Although they are important in their own right, as you will see in subsequent chapters.)

Landscapes are usually painted in horizontal, or "landscape" formats, where the width of the paper is greater than the height (as opposed to vertical, or "portrait" formats, where the height of the paper is greater than the width). This is not always the case, but it helps to think of a landscape as being broad.

In most cases, a landscape will include sky and land in varying degrees, and their relationship has been discussed in this book (see pages 56–58). The scene will probably have a background (sometimes just a sky), a middle ground (what is happening in the distance), and a foreground (what is happening nearest to the viewer).

The relationship among all three elements—as well as utilizing perspective and tonal changes—are all covered earlier in this book, but most important is the use of this knowledge when making decisions about your landscape subject.

Try to imagine what you will have to do when you paint the scene you are looking at. Where are the interest points, the shadows, the light, and the shadows? What information do you need to remember or record in a sketchbook or with photographs?

Imagine that you are going to paint your landscape with bold imaginative sweeps of your arm on a large surface: where would the background change into the middle ground and middle ground into the foreground?

It is useful to have a card "viewfinder" with you when looking at a landscape. This will help you view your painting as a finished picture with defined edges. The card frame that alters in size depending on the distance held away from your face can be made quite simply (see page 20).

You can often achieve the best results by making quick watercolor sketches on site, noting colors and details, and then completing the final painting in the studio. However, if you do get the chance to spend a whole day working quietly on your own outdoors, do give it a try. The results can be very different to your considered view when back in the warmth of the studio.

Try painting the landscape from your window. If you have a permanent scene, the same landscape can be painted throughout the seasons without going outside. Keep all these paintings and compare them year after year to chart your progress. Paint outdoors as much as you are able as this will give a fresher, more spontaneous feel to your paintings.

## My greens look dull.
## How can I get them to look more vibrant?

**Greens are particularly important for landscape paintings, and finding the right green for a scene is not always easy. Don't automatically try to recreate the colors you see in nature. However, it is important that whatever color you arrive at should reflect what you see, and the sparkling greens that we see in summer, along with the more lackluster fall variations, should be re-created successfully and realistically in your paintings.**

1 Green is a composition of blue and yellow, so try mixing any combination of the blues (Prussian blue, cerulean blue, French ultramarine), with any of the yellows (cadmium yellow, yellow ocher, Winsor lemon, etc.). Then try using a pure yellow or blue as highlights or as a wash.

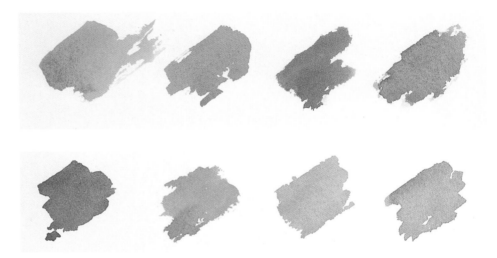

2 Try mixing Payne's gray with new gamboge for a darker green hue. To darken greens generally, try adding burnt sienna.

### ARTIST'S NOTE

There are three important factors to consider: the contrast among the greens, the amount of foliage, and the suggestion of background or distant light. Do not try to produce an enormous range of greens composed of complicated mixes. Always refer to your favorite simple palette and perhaps add a new green you have experimented with and know will provide you with a range of greens throughout your painting.

3 To make your greens look vibrant, don't paint all the spaces in the foliage; leave gaps and specks of light. Simplify your shapes and remember that light casts shadows, so greens can be made to look bright by contrasting them with dark areas of foliage. Be aware of what actually makes up a sunny day when you are painting foliage. The shadows in the sun are often blue, and the trunks and branches of trees are not necessarily pure brown. Leave areas of white paper so your greens can sparkle, and try thin glazes of similar hues to "warm up" your greens.

**Below** *The Auvergne* by Moira Clinch
Strong contrasts between warm and cool colors and light and dark
values lend a vibrant mood to this sunny landscape in southern France.

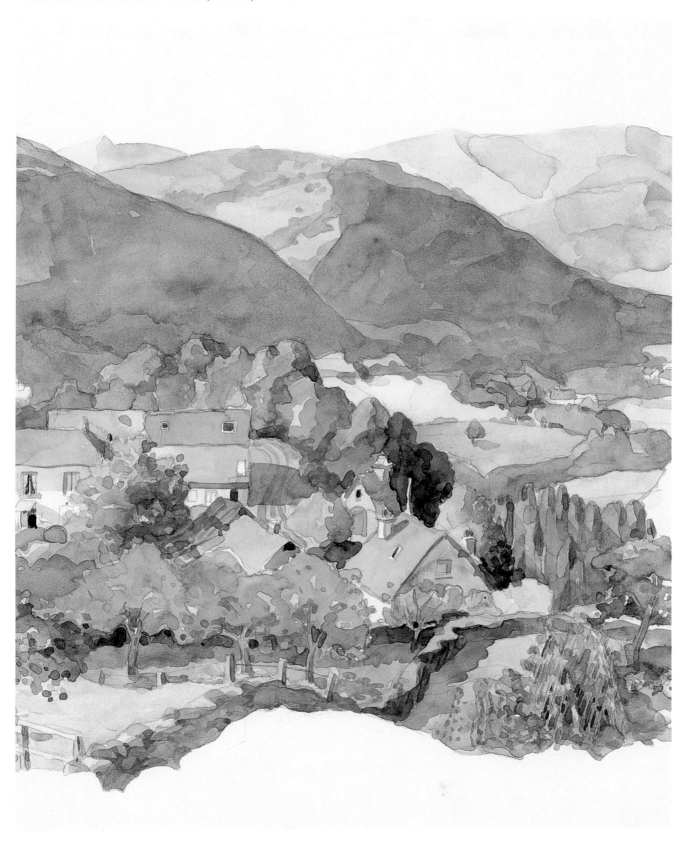

# I have trouble painting clouds, and the sky always seems divorced from the rest of the painting. How can I remedy this?

**As with most watercolor subjects, experimentation is the key. Take the time to try out various methods of painting skies as part of a landscape. Many students treat the sky as a separate problem area when in fact it is an integral part of the rest of the painting. Very often an initial wash can be left as the sky—with no further treatment—as just part of the background.**

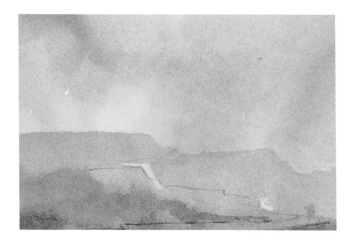

1 Try painting wet-into-wet, starting from the top of your tilted board. Allow your sky colors to run into the rest of your painting, from sky to land, picking up the sky colors in the rest of your painting. Don't be afraid to use other colors in the sky (light red, Payne's gray, or raw sienna, for instance).

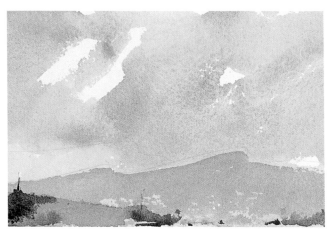

2 Clouds can be created by simply leaving the white of the paper untouched or by using a dry-brush technique to lift off paint from the initial wash to the sky area so that the original white of the paper shows through. The same technique can be applied using a paper towel or a sponge.

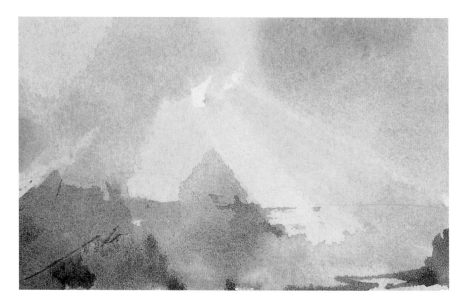

3 Sunlight, which backlights the clouds and sends rays toward the land, is a common sight, and this natural effect can dramatize your sky and throw light in patches on the landscape below.

**ARTIST'S NOTE**

Do not paint around clouds as though they were "islands" in the sky. Be observant and make a note of what actually happens in the sky above you. The sky is not always blue, and clouds are not always white. Very often the clouds reflect the colors of the land below and are not floating in space.

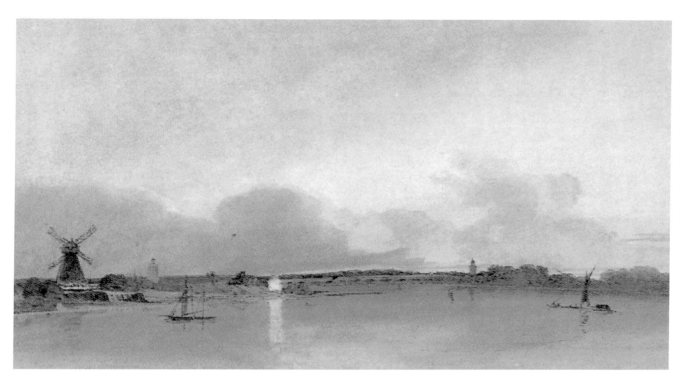

**Above** *The White House, Chelsea* by Thomas Girtin
Girtin worked with only five colors—black, monastral blue, yellow, ochre, burnt sienna, and light red—to create subtle evocations of atmosphere. But he also captures the essential separation of land, sky, and water in his use of tone and form.

**Below** *Evening, Pantygasseg* by David Bellamy
The sky here suffuses the outer outer twigs and branches of the trees with light as the clouds above crowd down on the landscape to convey a sense of the gathering night.

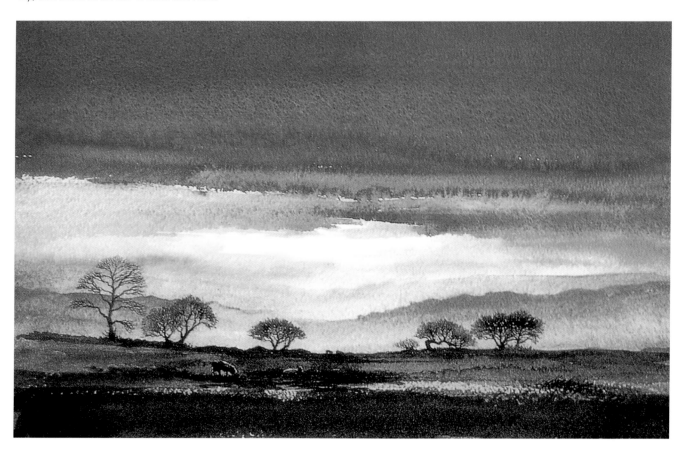

I have trouble painting clouds, and the sky always seems divorced from the rest of the painting. How can I remedy this?

# When painting outdoors, how do I deal with changing light situations? What are the best seasonal subjects?

Watercolor is light and portable, making it a good medium for painting outdoors and for capturing those fleeting glimpses of light that capture our imagination. Traditionally, outdoor subjects have been linked to the seasons: spring gardens and flowers; fall trees with warm colors; winter storms and snow; and soft, lush, summer landscapes. These are all appropriate and suitable subjects for watercolor painting. But why not try mixing the conditions in different pairs and concentrate your mind on the light and how it changes everything in your vision?

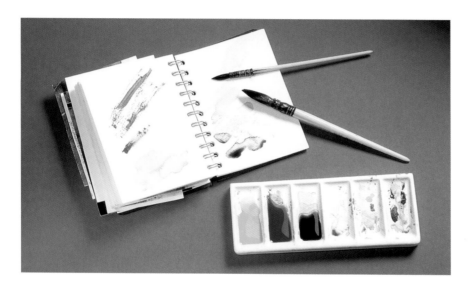

1 Experiment until you find mixes that please you, and remember to mix enough of your color washes to last for the duration of your painting. Keep some record in your notebook of these mixes, and be organized in your record-keeping. The discipline of recording your favorite mixes in a notebook will help you in your painting.

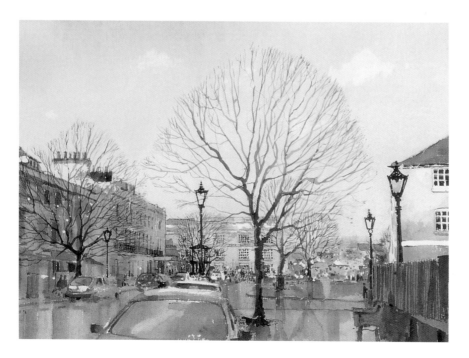

2 Summer rain and winter sun are more dramatic because of the enhanced contrast—bare branches in the sun are more of a challenge to paint than foliage in the sun. Think about opposites and look for the unconventional: a broken-down tractor can be more interesting than a working one. There is nothing as uninteresting or flat as perfection.

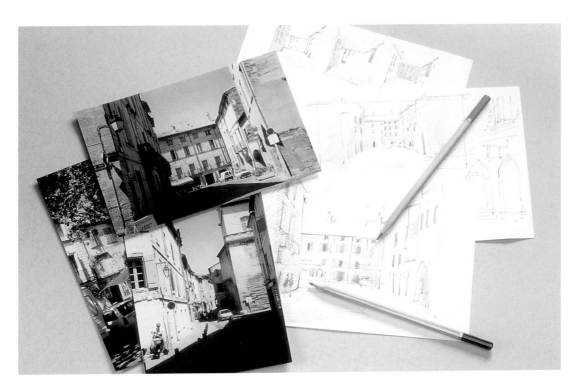

3 If you find that your outdoor painting needs to be finished in the studio, you may want to keep a record of your chosen scene by taking photographs or making quick sketches to record shadow positions and other visual clues. Be methodical about this.

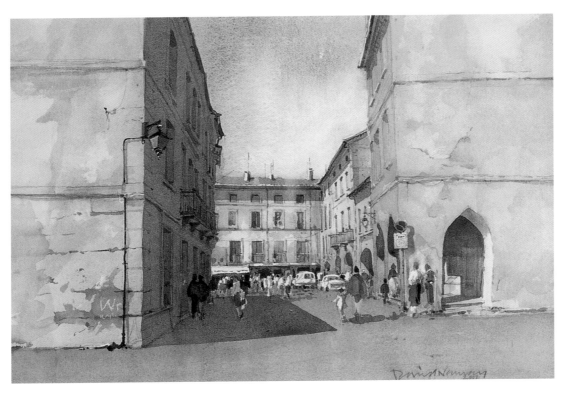

4 This finished painting was completed in the studio using notes about shadows, colors, and details denoting the time of day. This view could not have been painted *in situ*, as the desired viewpoint was in the middle of the road! Quick sketches, photographs, and some notes about wall surfaces were necessary to complete this painting.

When painting outdoors, how do I deal with changing light situations? What are the best seasonal subjects?

# Demonstration: A summer holiday in St. Lucia

This is a summer landscape that conveys all the elements one associates with summer. As with all paintings, put yourself in the mood: feel that you are on this beach and can hear the light breeze rustling in the palm leaves. The main emphasis in a painting like this is the overall impression of summer sun and clear skies. In many cases, this means that the sky can be a very plain blue wash—but employ some gradating or wiping off techniques in order to make the sky lighter at the horizon. Remember to use and soft edges (*see* page 58) and misty backgrounds—they all add to the final atmosphere of your painting.

1 Start by painting in the sky. To obtain a lighter horizon, turn your board upside down and tilt it at approximately 10 degrees. Paint an even and overall wash of cerulean blue for the sky area and allow to virtually dry while still in this position.

2 Turn your board right side up, and fill in the greens of the distant hills with a mix of cerulean and aureolin yellow. Paint the sea with Winsor blue and use a little blue on the far distant hills to give a misty, distant feel. Dab off any excess paint with a paper towel if necessary.

3 Paint the sand in the foreground with raw sienna and the boats with greens, blues, and oranges. Apply the colors delicately, stroking in the same direction.

4 Strengthen the background and paint in the tree trunks with upward strokes (in the direction of growth). Use a Payne's gray and aureolin yellow mix for darker greens in the foreground.

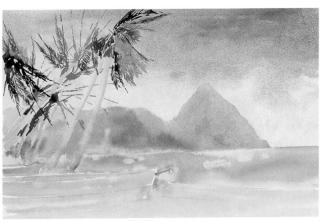

**6** Now is the time to reflect on the painting so far and make decisions about its progress. Allow the painting to dry before moving onto the next step.

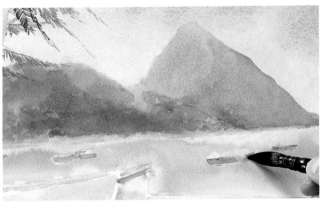

**5** Using a mix of viridian and olive green, paint in the palm tree leaves and branches with a flat brush, using the edge of the brush for the fine lines of the leaves. Use the brush in a sweeping motion for wider areas of foliage and dark clusters, and remember to keep varying the color of the leaves to add interest.

**7** Use a rigger for very fine leaves or branches. Dampen the summer foliage area and add further greens wet on dry using a mixture of Indian yellow, aureolin, new gamboge, and cerulean blue. Also paint in some more detailing on the boats such as shadows using slightly darker variations of the hulls' colors.

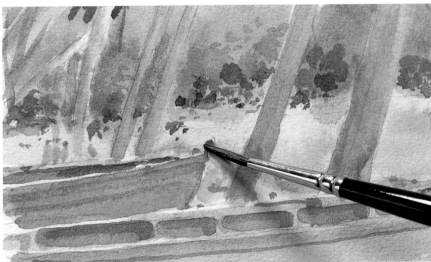

**8** Strengthen the color in the beached boats and details in the other boats. Use any of your palette colors to dot in areas of interest along the shoreline, in the boats, and so on. This helps keep the color scheme consistent and coherent. The boats are beginning to look more three-dimensional.

9 Paint a further wash of Winsor blue (red shade) over the sea area, making sure you have a medium-size round brush and a small round brush at hand. Paint the majority of the sea with the large brush, avoiding the boats and making sure that you create a hard dark edge on the horizon. Change to a small brush for details or ripples in the water, blending into the previously painted color of sea near the beach.

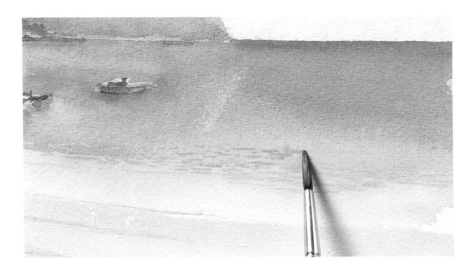

10 Paint a line of small waves gently breaking on the shore. Add shadows using French ultramarine and Payne's gray, particularly on the tree trunks. Use a large brush and then break the hard edge of this shadow with a flat brush to indicate the texture of the trunk.

11 Add shadows and an indication of ravines in the distant mountain. Continue to add texture to the foreground by rolling on darker greens, and create the curve of the boat in the foreground with a light shadow wash of Payne's gray, starting at the stern and blending in toward the prow.

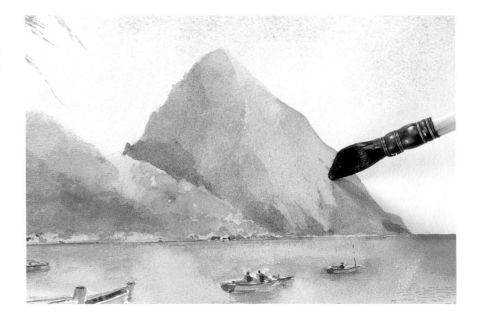

12 Using Chinese white with a small brush and the dry-brush technique, create surf at the edge of the small waves. Use a craft knife to create other white marks, such as a distant yacht and buildings on the hillside.

13 Add cadmium red and cadmium orange from the tube for distant beach features, and apply Chinese white for the buildings. Finally, define any areas to be enhanced and ropes from boats with a pencil.

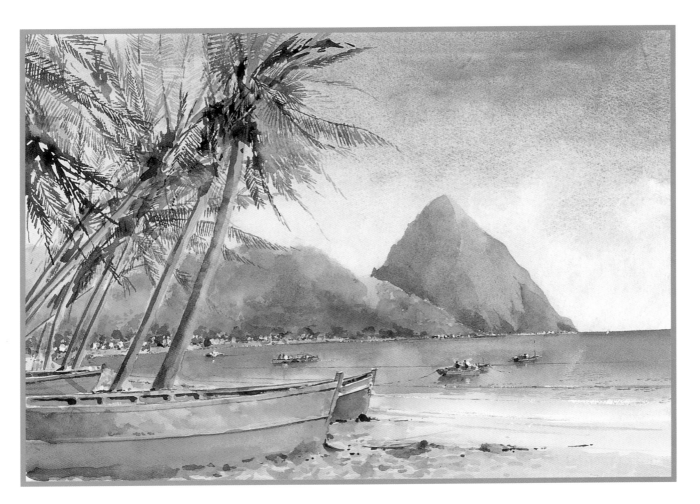

14 The light and airy feel of this painting is achieved through the use of a restricted palette of light colors. The clear blue sky, gradually fading to a delicate shade of off-white at the horizon, creates an effect of infinite space. The boats in the foreground break up the monotony and successfully contrast with the distant features on the hills.

Demonstration: A summer holiday in St. Lucia    89

# How can I paint convincing trees and foliage, whatever the season?

**What you have to avoid is the common problem of defining each leaf or branch or each individual blossom or bud. Our brain takes in a lot of information when we look at foliage, but in general we are left with an impression of a mass of color or a sketchy view of light between the trees. It is this overall impression that you need to show when painting such a scene; the viewer's brain will adjust by adding details accordingly.**

1 Try painting very pale colors to begin with, allowing differing greens to mix on the paper (wet into wet) and applying different greens wet on dry. Make sure that generally the greens are lighter toward the extremities of the foliage and darker in the center or where the branches are thicker.

2 Allow light from behind the foliage to creep through into the mass of green. Allow dots and dashes of green to impose on the sky in the same way.

3 Complete your initial washes and build up your light and dark areas before detailing. Plan and paint the background before applying the foliage color, and allow the two to merge slightly. In the same way, paint any branches and allow the foliage color to merge slightly while it is still wet.

**4** With winter trees, remember that twigs and branches can make interesting shapes. Paint with a rigger in the direction of growth, or perhaps use a crow quill pen for the finest marks against a clear sky.

**Below** *Lakeland Tree* by Moira Clinch
A combination of wet-into-wet and wet on dry gives excitement and variety to the paint surface. The granular effect caused by overlaying washes gives texture to the large tree trunk, and the leaves painted over washes achieve a dappled light effect.

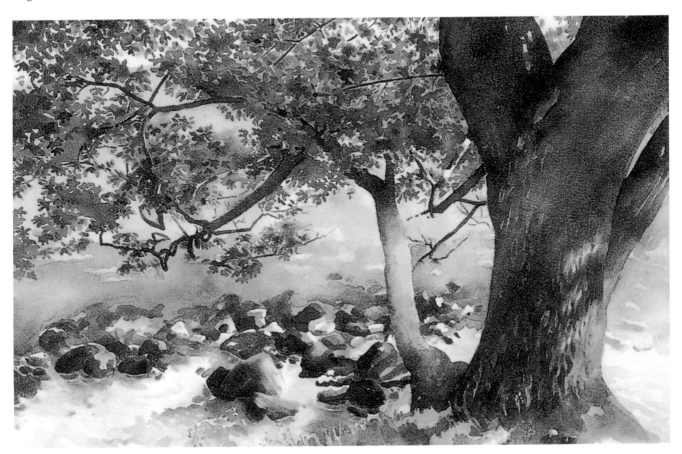

## How do I tackle the colors in a snow scene and create the sense of falling snow?

**Snow scenes are a favorite watercolor subject. Masking fluid is a useful material to use when painting snow scenes. Flick masking fluid onto the page with a toothbrush; when rubbed off, a sense of falling snow will be immediately apparent.**

1 The typical snow scene can be very predictable and uninspiring, so before you get on to techniques, be careful to choose a snow scene that exaggerates the effect of snow, perhaps in an unconventional way. Snow can be very dirty and grubby, so don't be afraid to show this aspect of it, as it only enhances the areas of pure snow elsewhere.

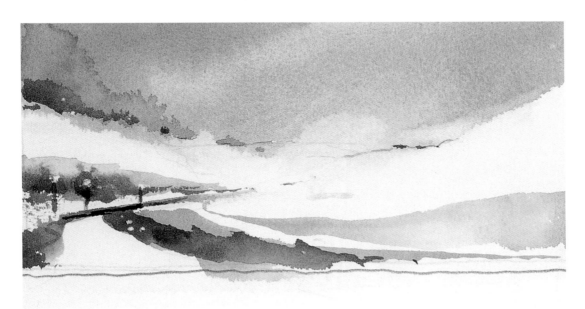

### ARTIST'S TIP

As with clouds, do not paint around white areas of snow; leave them as shapes of white against a dark background.

2 This is a subject matter where a spattering of masking fluid over the entire scene is appropriate. Try using a toothbrush or flicking the fluid on in a random manner, making sure that the blobs are of different sizes. Also apply masking fluid to the tops of posts or other areas where a small amount of white is concentrated. Final flicks of white can be achieved with a craft knife or scalpel, but do not overdo these techniques.

3 The sky will probably be very dark and leaden, so allow your wash to be infused with other colors. Use Payne's gray with French ultramarine, and even add some burnt sienna in places. Blue mixed with brown produces very good colors for snow scenes. Experiment with these and do not be afraid to use other mixes in with the dark areas of your painting.

4 Make sure that you have the same shadow mix throughout the painting; it is important to be consistent. Be careful to observe the way in which shadows form in the snow with both very defined edges and some gentle curves on the flat snow areas.

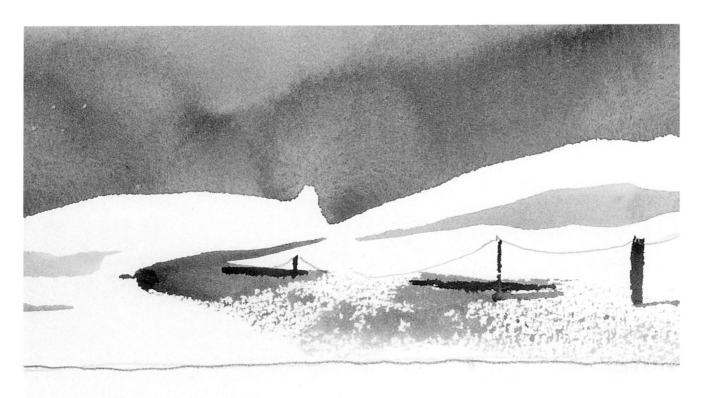

5 Use a dry-brush technique to indicate disturbed snow on the roads or footpaths. The trampled snow forms an effective contrast with the pure snow and adds realism to your painting.

# Demonstration: **Snow scene with trees**

The important thing here is to delineate the amount of snow that will remain white. To begin, make sure that any large area of snow will remain as the original white of the paper. As the painting progresses, most of this stark white will be softened with varying shades of gray. In the end, there may be very little pure white, although the painting will appear to consist mainly of white snow. Notice the composition, the rule of thirds, and the framing of the final image, all covered in previous chapters.

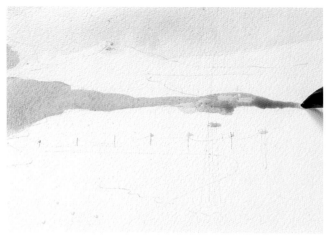

1 Prepare your drawing and sketch the outline of the hills, the areas of trees, and the buildings. Apply masking fluid to the buildings (these can be random dots that will turn into white roofs later) and to the tops of the posts where snow will have settled. Spatter masking fluid over the entire painting with a toothbrush, and add some larger dots with an old brush. In this painting a lot of white paper is left untouched, so do not allow color from the washes to dribble into these white areas. Apply a wash of ultramarine and raw sienna in the sky area only; then add burnt sienna to the sky on the left-hand side to darken it with a sepia tint. This contrasts with the light, bright sky on the right-hand side and indicates an impending storm. It also forms a contrast for white snowflakes against a dark background.

2 Paint the landscape details with hard edges against the white snow background. Make sure these edges are crisp and sweeping.

3 Paint the trees wet-into-wet and define the branches, allowing some of the details to merge with the general tree shapes while some remain clearly defined as branches and twigs. Much of the wintery mood evoked by the finished painting depends on the starkness of the bare branches.

4 Darken the sky even further with sepia, burnt sienna, and French ultramarine. Make sure you check the painting by viewing it vertically from a distance every so often to see that the overall balance of color and composition are right.

5 Darken some of the right-hand sky with directional strokes using a rolling brush. Be as quick as you can with these strokes; they must not appear labored.

6 If you are happy with the painting and feel that no further additions need to be made at this stage, allow all surfaces to dry before moving on to the next stage.

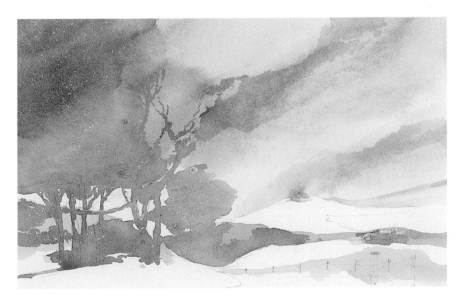

7 Intensify some of the sky blues by introducing heavier color on a dampened surface. The sky color should not be even but made up of contrasting areas, to add interest and movement and to lend atmosphere.

8 Strengthen the tree trunks and the post with burnt sienna, sepia, and Payne's gray. Allow some of this color to disperse a little but wipe off any excess with a paper towel. Make sure that the color is very defined in the snow.

9 Allow everything to dry at this stage. The sky on the right-hand side looks empty, and the picture is not "framed." To remedy this, add winter tree branches overhanging from the right in the foreground.

10 With careful, measured brush strokes, paint in tree trunks to partially hide the distant buildings, using a flat brush on its edge. Some trunks will appear lighter as the paint runs thin on the brush.

11 With a mix of burnt sienna and Payne's gray, sweep along the road with a dry-brush technique to create muddy areas of disturbed snow. Stroke in one flowing movement; do not go back over this stroke or your road will become one solid line of color.

12 Add twigs and branches with a flat brush, and use a crow quill pen to pick out the finest details. These small additions will bring life to your painting.

13 Add wires to the fence and additional dots and marks in the snow with a crow quill pen. These will be the darkest colors in the whole painting.

14 At the very bottom of the nearest trees, spatter a dark mix of sepia onto some white snow areas with a toothbrush.

15 Mix a pale wash of French ultramarine and Payne's gray for shadows in the snow-white areas, painting with crisp, smooth edges.

16 This painting illustrates the use of spattering and dry-brush techniques, as well as how to create a sense of atmosphere by organizing the darks and lights. Notice also that the trees on the right frame the picture and give it structure. The atmospheric conditions of a bleak winter's day are cleverly reproduced thanks to a number of different techniques.

**Above** *Road to the Sea* by Milton Avery
Using watercolor washes over a charcoal drawing, Milton Avery abstracted his subject but kept the essence of the snow-swept expanses and the clusters of trees picked out in the snow.

**Below** *Warm Winter Tones* by Margaret M. Martin
Watercolor is the ideal medium for conveying the feeling of a rapid thaw that is evident in this painting. Notice that the warm stucco color of the houses is reflected in the pools of water at the edge of the road. The brightness of the scene is defined by well-controlled washes.

Demonstration: Snow scene with trees     **99**

# 6
# Portraying a townscape

Townscapes offer exciting and almost endless possibilities for watercolor painting—partly because of the subject matter but mostly because of the interesting viewpoints available. In a general landscape, the fact that you are encompassing a broad vista means that the viewpoint is very often fixed at a general "horizon" level. With a townscape the view can be either straight ahead, up, or down, and the intricacies involving perspective are endless and fascinating.

A knowledge of the basic principles of perspective and architectural drawing are an advantage, but not essential. The important thing is the overall atmosphere and feeling of a town or city.

Some artists may be concerned about the complexity of a street scene. Try focusing on just one element in the street and allow the rest of the detail to merge with the background. Shop fronts, market stalls, and old churches can be highlighted without completing a whole street scene.

Be on the lookout for less obvious views in the town or city. Industrial areas, dockland buildings, and run-down areas of decay or neglect often offer wonderful shapes and colors.

The townscape changes from hour to hour as the shifting light falls on buildings and cars and the reflected shadows fall across buildings in sunlight. Fog and mist can also add an eerie or romantic element within a street scene.

Townscapes are ideal for painting at night. Whereas a landscape would be mostly dark (other than moonlight), a townscape may have street lighting that throws all manner of shadows and lights on adjoining buildings and road surfaces.

Also think of the possibilities of the effect of rain on buildings, on reflections in pavements, on umbrellas, and on groups of people huddled in shops or under awnings. And consider how interesting rain at night, caught in the lamplight, can be.

As you walk through a town, be aware of everything that is above shopfront level. Make a note of signs and billboards. When you are in a high-rise building, look at the scene below you, and imagine what you would concentrate on in your painting, what happens to the perspective, and so on.

There are a multitude of possibilities, and the more you explore, the more fascinated you will become with townscape painting. Develop your skills at drawing individuals and groups of people, particularly in a quick and easy style. Including people in a townscape, although not essential, gives a sense of scale and also offers clues to the time of day and year, all of which will enhance the interest of your painting.

# What townscape view should I adopt?

**This is a very important question that will make or break your painting of a townscape. Perspective is all important here, together with your viewpoint in the townscape.**

1 An elevational drawing or painting (a view of the front of a building, for instance, where very little or no perspective is involved) is a common subject. Here the interest is often in the architectural detailing that is found on the building or in something that is in front of the building.

2 A drawing or painting from street level is a common viewpoint. In this case, there is the added dimension of the height of the buildings, as well as the distance conveyed as they recede.

**ARTIST'S NOTE**

Your focal point can be emphasized by color, interest, or compositional tricks. When you next consider what townscape to paint, imagine that you are looking through a camera viewfinder, or use a cardboard cutout to frame your view; then try to imagine the final painting. Take some time to do this, and try not to end up with the usual postcard image. Although well composed, it can sometimes lack any real interest or impact.

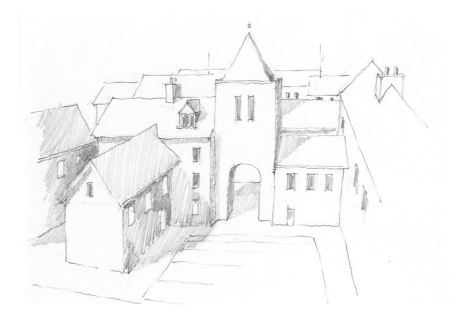

3 With townscapes involving several buildings or roads, the eye line is important; that is, you need to note the position of your view in relation to the ground level. Drawings or paintings of rooftops or from high-level windows are popular, but be sure that your perspective view of the streets below is correct.

# My buildings look like boxes.
# How can I make them more realistic and interesting?

Most buildings in towns have some architectural details, to a greater or lesser extent—and usually buildings have been adapted, altered, or added to during their lifetime. Make sure that you record not only the masses of the buildings but also their detail. It is this detail that throws shadows both onto the sidewalks and roads and onto adjoining buildings, casting the image of an elongated version of the building onto another surface. It is the combination of all these factors that can change a common building shape into a recognizable townscape building.

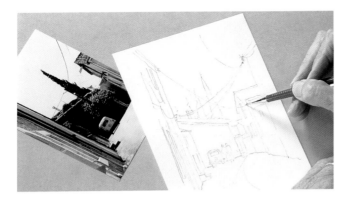

1 Telephone and electrical wires, chimneys, television and radio antennae, gutters, drainpipes, and overhanging eaves and their shadows are important elements to record. Try to focus on what you are drawing; then execute all these details as quickly as possible, even if only in a sketchy form. Break up the foreground in front of your buildings with people, cars, or trees if possible.

2 Once you have laid down your background colors for the buildings, try using the same colors for the shadows in all areas of the building. Do not strengthen or weaken the wash in darker areas, but wait until dry and then cover the darkest areas again. Do not be too careful about shadows, as they often highlight imperfections in flat wall areas and so lend a sense of realism to the view.

3 In the completed painting above, notice that the telephone wires, the cables, and their shadows on the ground "fix" the buildings in position and give them some solidity. The painting is also given a sense of realism. See how the shadow on the right-hand side is reflected in the road, and on the left-hand side it's reflected under the overhang of the roof, suggesting the depth of the eaves. By painting this line in a freehand manner, the undulations in the uneven wall are shown.

# How do I represent tricky subjects like cars or passers-by?

The first rule is: don't be afraid, just do it. Cars are not easy to draw or paint, and so many artists labor over the drawing process, with the result that the vehicles are too dominant and become an area of excessive attention or annoyance. People, on the other hand, are essential to most views. They, too, can assume too great an importance, however, unless the focal point of the painting is a person or group of people. Generally speaking, it is best not to overwork these subjects.

## VEHICLES

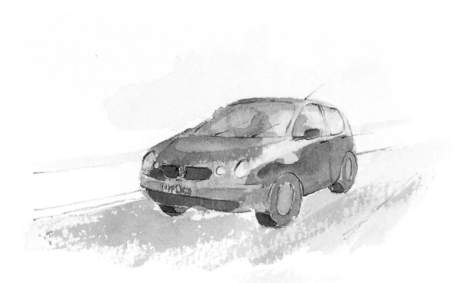

Treat vehicles in the same way you do buildings: paint them quickly and lightly and add only enough detail to signify a car or truck, ensuring in your initial sketch that the scale is appropriate. Do not paint vehicles that happen to spoil your composition; just leave them out or add one in where you think it serves a useful purpose (like hiding something that is even more difficult to paint). On the left, the car is painted in a fairly detailed manner; this would attract the attention of the viewer and become the focal point of a composition. In the loose painting below of the same car, the vehicle could be lost in a townscape and not be recognizable as any particular make or type and thus not draw attention to itself.

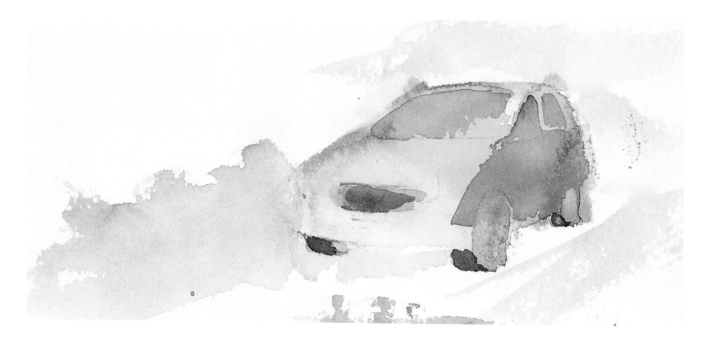

## PEOPLE

1 Paint people in a quick and loose manner so that they can be simply popped into the painting wherever you wish. Just apply three or four dabs of paint in a quick and confident manner to create a head, a body, and a suggestion of feet.

2 Practice painting different types of people: men, women, and children. Add details as required, being careful not to complicate the figure and thereby draw too much attention to it.

3 Even pets, loosely painted, can add interest and detail. Keep them sketchy and do not overwork them. What you are painting is a suggestion of a dog, not a detailed rendering.

4 Try this technique with groups of people in a line or in a crowd. Play around with contrasting heights and positions within the painting, but keep the figures loose or they will attract too much attention and will detract from the real focal point of the painting.

# What other factors influence my townscape?

**Think about the feelings you get when walking through your town or city; its focal points and its peculiar attributes. What are the visual clues that remind you of where you are? Try to include these aspects of your environment in your paintings. What is appealing about the town at night or in the rain? Towns are made up of walls of every conceivable kind, and these walls are often covered with a variety of signs and symbols and are finished in a variety of materials. Concentrate on these elements.**

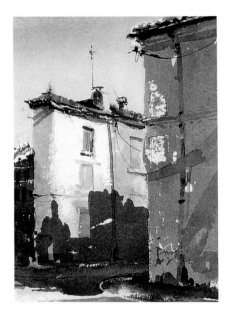

1 Include advertising hoardings or posters in your view, and don't forget that they are often peeling off the wall. Try to reproduce this effect.

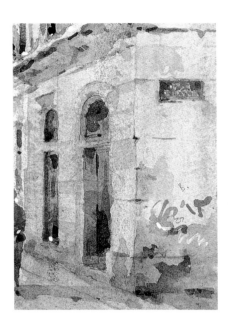

2 Don't be afraid to include markings like graffiti—it need not be readable—but it adds a touch of realism to your painting. Wall finishes such as brick, plaster, and stone should not be passed over as simple flat surfaces. Try to experiment in creating different surface finishes.

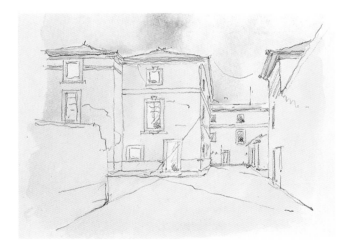

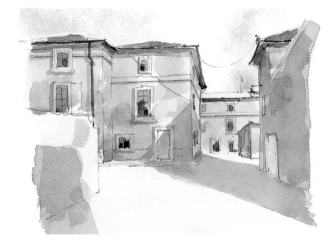

3 Here is a notebook sketch of some town houses with rendered walls that have been given a light wash of raw sienna.

4 Paint the wall with raw sienna washes, but vary the wash with some other color or colors (burnt sienna, raw umber, or sepia). Let some of the underneath color show through.

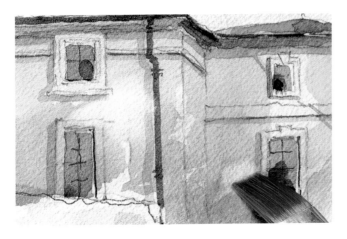

5 Let the colors dry, and then use a flat brush and paper towel to wash off and dab away some of the paint in specific places. Add some darker tones to signify the wall under the plaster. Here, shadows have been introduced to help the overall effect. Add any lines and cracks in the plaster with a fine brush or pencil.

6 Experiment with making stone or brick shapes with the lifting-off technique, using a flat brush, some clean water, and a paper towel.

7 Don't forget that walls are often full of stains and blemishes. Try dampening your paper and dropping on color, allowing it to fall in the same way that rain does to cause a stained effect on the wall. Fully tilt your board; when nearly dry, dab off any unwanted areas of paint to exaggerate the dribble or stain.

8 An indication of reflection in wet pavements can be easily achieved using the same technique with the flat brush. Make sure that the areas that have been lifted off are vertical and that they follow the lines of the reflected building, particularly emphasizing corners or columns.

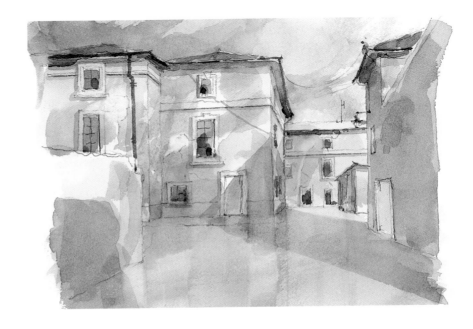

## My completed picture is satisfactory, but the colors I have tried to capture from life look unnatural. What have I done wrong?

The first point to raise is that it is probably almost impossible to reproduce exactly what we see, especially in nature. A painting, no matter how accurate, never really repeats precisely what is seen with the naked eye. Forget about replicating exactly what you see and try to conjure up the mood of the view with colors that seem to capture the feeling at the time. If you spend too long trying to match a color exactly, then the moment will have passed—changing weather conditions may have altered the initial hues. Try to get an overall feeling for the scene and go boldly forward.

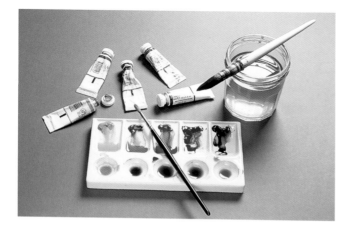

1 Try using a restricted palette. You will find with experience that you can reduce the number of paints you use to suit your style. Although there are numerous paints available, you may end up by using about six, with the addition of special colors for certain purposes. The colors used here, from left to right, are: raw sienna, burnt sienna, permanent magenta, French ultramarine, and Payne's gray.

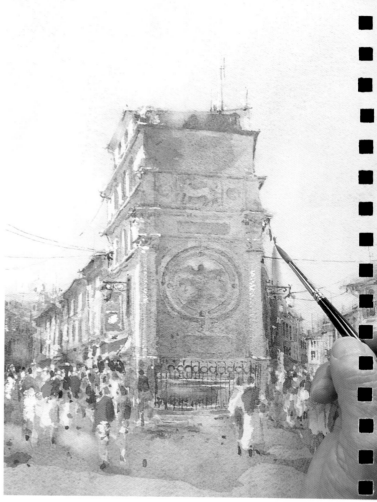

2 Using a restricted palette, you become much more confident in the colors you are mixing, and you can judge how to darken a yellow by just the right amount without thinking. This leaves you free to focus on the overall color composition, which is all important.

3 Don't be afraid to add "dots and dashes" of colors to your painting to relax the eye and reduce the impact of "exact" colors. Here, dashes of cadmium red were used on people on the street. This red is counterbalanced by the addition of some red flags diagonally opposite.

**Above** This striking painting of an abandoned watchtower uses color to heighten the mood. Although sketches for the painting were made on a sunny afternoon, the artist thought that the desolate and deserted nature of the building demanded a more dramatic backdrop of the heavy, threatening sky and the rich, strong foreground.

My completed picture is satisfactory but the colors I have tried to capture from life look unnatural. What have I done wrong?

# Demonstration: The arches at Uzes

This painting incorporates several townscape features with a slightly unusual viewpoint; much of the painting is a vague depiction of arches, and only glimpses of the street are seen between the arched colonades. You do not have to paint everything in detail in a scene like this. Look for interesting viewpoints in your townscapes, noting some of the elements that make up this scene: architectural elements, people, cars, storefronts, shadows, and interesting wall surfaces. Of all these ingredients, probably the most significant is the wall surface within the arched area.

1 First, prepare your paper. Set your board at an angle, and completely wash the paper with clear water using a mop or a large round brush. Allow it to dry almost completely.

2 Using a mix of raw and burnt sienna, apply a random wash across the whole page. Add in any interesting dabs of color in specific areas if you think they will set the tone for later work.

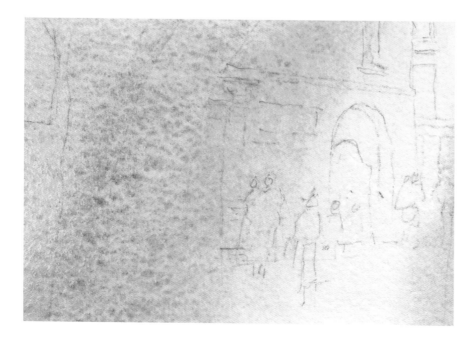

3 Add ultramarine to the darker arch areas, noticing the granulation that has taken place in this closeup. Granulation medium is available to add to your wash to create this effect, but take care not to overdo it. The important thing is subtlety, so it is important to be restrained.

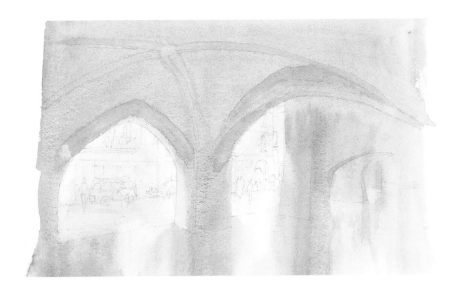

4 The painting is now set. Notice that the vertical washes have run and act as reflections on the polished stone floor under the arches. Be aware of the direction of the light (here coming from the left) for future detail. When the washes are nearly dry, redefine the arches by "drawing in" with a further weak wash of French ultramarine, just as an indication for later work.

5 Paint in loose figures and vehicles, and reinforce some details on the buildings. Do not overdo any details at this stage; just establish the general shapes.

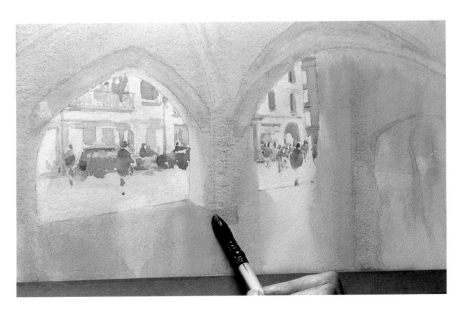

6 Paint a light wash of alizarin crimson over the stone floor under the arches to reinforce a change in texture from the road surface. This light wash will enhance the appearance of reflections in the stone surface of the walkway.

Demonstration: The arches at Uzes   **111**

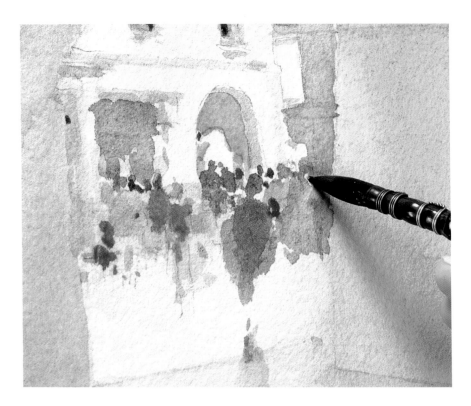

7 As you continue to paint the shadow areas, notice how very often windows are dark when in the sunlight and light when in the shade. Allow the painting to dry. Paint the shadows as you see them, but remember that shadows also vary in tone, so be observant and alter your washes accordingly. Allow areas of sunlight to sift through the shadows if possible.

8 The painting is now at an interesting stage in that most of the elements are in place. Study the painting for a while, and remember why you chose this aspect. The next stage will be to fill in chosen details that could be the focal point of the scene.

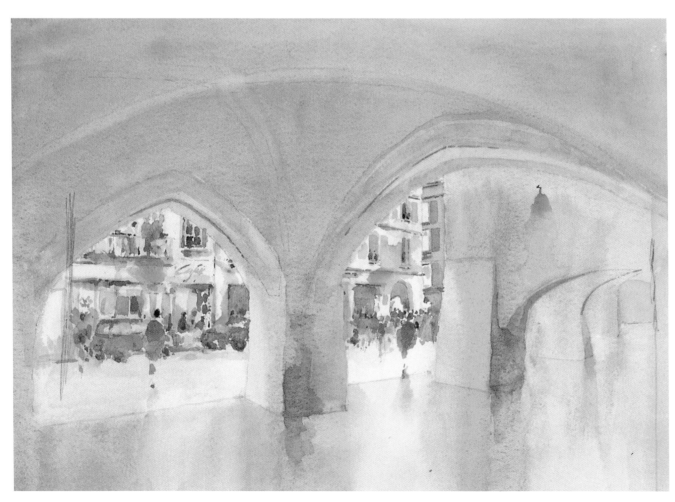

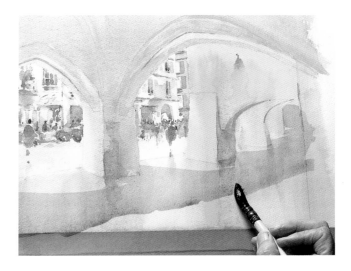

9 Keep darkening under the arches with Payne's gray, French ultramarine, and Vandyke brown, and introduce shadows onto the floor area under the arches.

10 Add details to the figures, vehicles, store fronts, and buildings, increasing color and additional layers of interest as you paint with a brush or crow quill pen.

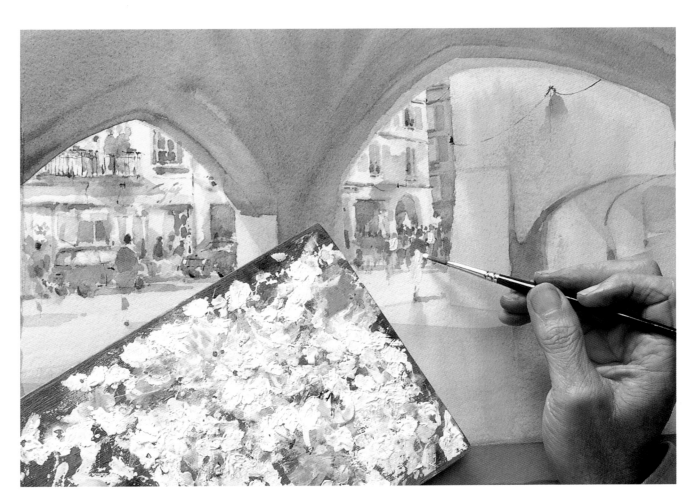

11 Using a fine brush, add some Chinese white to highlight small areas in the painting, such as car windows and people. When using Chinese white, it is a good idea to squeeze it onto a small board in order to keep it separate from the rest of the colors. Remember that Chinese white is opaque and will affect all your mixes if it is introduced, so keep it separate from your other colors and rinse your brush after use, changing any water that has been used.

**12** Add some cadmium red straight from the tube for the vehicle reflectors. Be careful to not overdo this kind of detail—the car is not the most important element in this painting, and you do not want it to become the focal point of your painting.

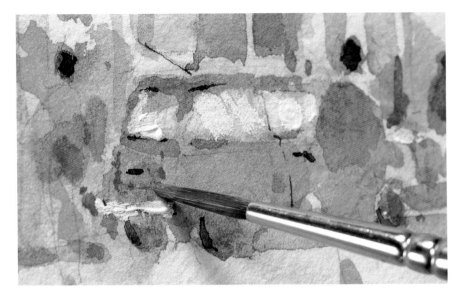

**13** Mix Indian yellow and burnt sienna on the brush and apply it to the dampened wall to suggest stains and other marks. This part of the scene is the most significant element in the painting and so no further detail will be added in the distance to detract from this wall.

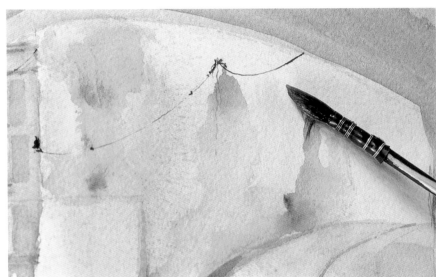

**14** With a flat brush and clear water, draw out a line to emphasize rib vaulting details, dabbing with a paper towel to remove moisture as required. Notice that the arches are beginning to look increasingly three-dimensional.

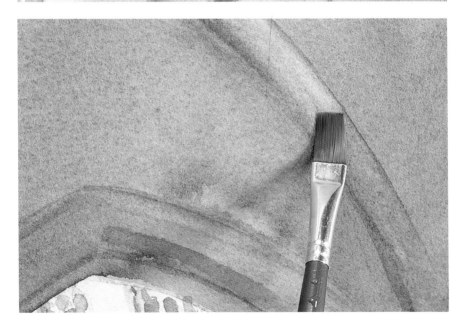

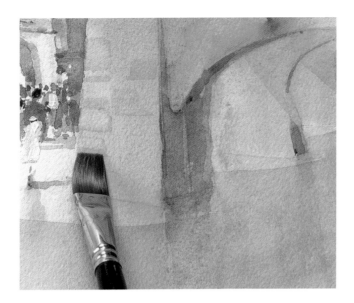

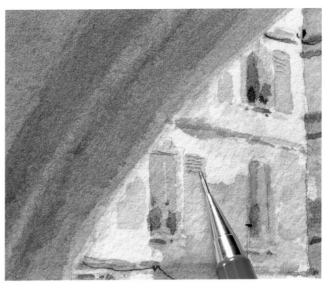

15 Using a flat brush with clean water, remove the paint on the wall by pushing the brush up and down then dabbing with a paper towel to create the effect of stonework.

16 Add further definition in pencil to the shutters and wires if required. Do not overdo this, as you do not want to detract from the important foreground wall.

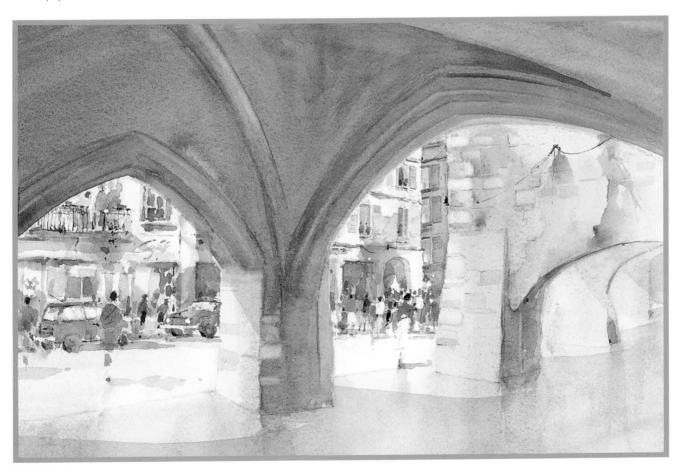

17 This demonstration highlights the following areas of interest: the appealing choice of view, the inclusion of figures and unobtrusive vehicles, and the detailing of the buildings. But the most important factor is the foreground wall.

Sometimes you select a view for a particular reason and yet when you start to paint, something else comes to the fore. Don't fight against this but rather allow this to happen. Do another painting to highlight your first impressions instead.

# 7
# Depicting a seascape

What is it about seascapes that is so attractive to watercolorists? Some painters seem to paint nothing else.

With landscape painting, you have a broad view, and with townscape painting, you have linear perspective and the endless possibilities of detail and complexity. With seascape painting, there is one vital ingredient that needs attention and that, of course, is water. Under the subject of seascapes, riverscapes, harbor views, and perhaps lakes and reservoirs could be included—anything where water is the main ingredient.

Seascapes may become a specialist area of painting, and many societies and clubs deal with nothing else. Watercolor is particularly appropriate for painting water, and I hope that some of the problems associated with this genre are explained here. As with all areas of watercoloring, try to convey what you see, and if you become interested in some specific area, try to explore the subject further by studying works by other watercolor artists or recording drawings in your sketchbook.

The varying moods of water need studying in detail, as there is a great difference between a rough sea with crashing waves and a calm mill pool with a surface like a mirror. Start experimenting by painting with reflective calm water.

Go to your favorite water view, and spend some time studying what actually happens on the surface of calm or gently moving water. Imagine yourself in your studio painting it—better still, take your paints with you, but do not do anything until you have observed exactly what happens. The reflections are not straightforward mirror images; the water is not blue but several shades of gray or brown, with surprising highlights of red and green and the occasional sparkle of white. Just imagine what happens when a boat disturbs this calm surface.

Practice painting these changing surfaces. In fact, you could collect a whole series of abstract paintings in water surfaces. You will find that they change every time you see them.

Boats—particularly old boats—are beautiful things but not always easy to draw. Rigging and boat paraphernalia are great watercolor subjects, but again need to be studied carefully. Do not rush into this waterscape world without taking it one step at a time.

Rough seas are difficult and have to be studied carefully to determine the amount of white paper that is to be left and how it can appear to be wild with spindrift and broken color.

The use of photography is most helpful here, because you are able to freeze the movement of water to study what actually happens to the surface. After all, your watercolor is also a frozen moment in time.

# Why am I never happy with my paintings of water and reflections?

**As with skies, water is an integral part of the landscape and not a separate element to be "filled in" with blue. When planning your painting, the area of water should not be left to finish later as a difficult subject.**

1 Make sure that your overall initial washes are allowed to fall from the top and middle of the painting into the area that is to be water, so that the reflections of the land are already recorded as a light wash and as a background to the finished water surface.

2 Allow the washes and general overall color background of the painting to dry; then concentrate on enhancing the areas of land and boat. You will then find that the water has already become a reflective still area and will appear to be very calm. What you do next with the water will determine the overall feel of the painting. It is important not to lose this feeling of stillness.

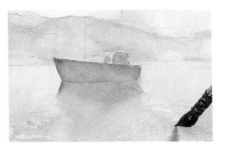

3 Remember not to overwork your paintings. You may wish to continue with the rest of the painting and leave the water as it is. If you want to show reflections of boats or buildings, then merge a darker wash while the paper is still moist. If the boats are in contrasting colors, remember to allow some of the color to wash into the water. With practice, you will learn to gauge the right time to apply these washes.

4 If you want to alter the surface of the water, mix a darker color of the existing boat surface. Repaint the boat hull and allow this color to run down the paper, thinning with clear water toward the bottom of the painting. Allow it to almost dry; then mix an even darker boat color and apply it in thin strokes, reversing your brush to indicate ripples. You could also use a crow quill pen if your painting is small in scale. Study the surface of the water, and make sure that your surface marks diminish in size in the distance until there are none at all. Add further ripples in the water using the colors you have used already, making sure that the disturbances in the water are more pronounced in the foreground.

# Q&A

## I want to capture breaking waves. How do I do it?

**Until you become completely confident, choose a view that will allow you to show breaking waves against something more static. Observation is everything here. What color is the sea? Probably not blue, but varying shades of gray and green. How dark is the darkest color? What is happening in the sky?**

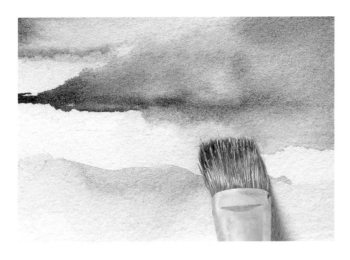

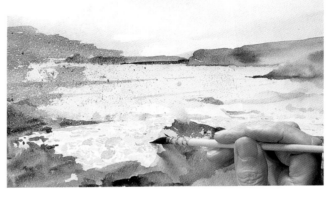

1 Apply masking fluid with a toothbrush to create sea spray, making sure that you have a fine spread, and allow it to dry. Paint in the general sky and sea with a gray-green wash, making sure that the sea is darker behind the spray. Allow the colors to merge, but avoid the preplanned white areas. Don't let any of the washes form an edge where they meet white areas except where there are rocks or distant hills. Gently wipe back the wash with a stiff brush to soften any edges as necessary.

2 Keep your paper just damp and fill in areas of rocks or outcrops, making sure that some of this color appears within the whites that have been left (in the same way that foliage is indicated in the sky, *see* pages 90–91). It is important to get the balance between the colors right, so that the scene has an even structure.

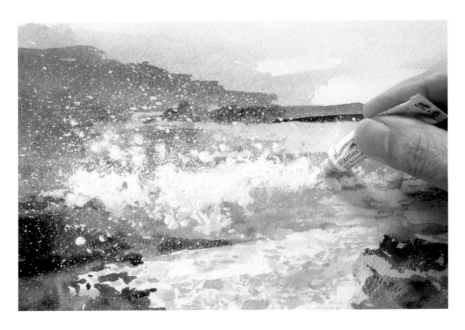

3 Allow your painting to dry, and rub off the masking fluid with your finger. Carefully apply darker mixes of the colors used where required to achieve the darkest part of the waves. Try using Chinese white to indicate spray, and pick out other highlights on the tops of waves with a craft knife or safety razor blade. Notice that the finished painting skillfully gives the impression of breaking waves, and the contrast between the white areas and the darker colors helps to produce this effect.

# How do I create complicated details on boats, such as masts, ropes, and stays?

**Remember the amount of detail that your eyes take in and how much your brain fills in when taking an overall look at something like foliage. The same is true with the general view of complicated areas like rigging and boat paraphernalia; you don't have to paint it all down to the last detail.**

1 When setting out your general areas of color, try to include plenty of variation where there is a complex array of shapes and dark and light colors, but don't be too fussy about it. A background of interest will have been laid down. Make sure you have the overall composition secure and allow it to dry. Dab random masking fluid marks to highlight paraphernalia on boats such as ropes, metal fittings, and similar details.

2 Add more dabs of paint to complex areas, making sure that the shapes you use are reflective of what you see, until you build up an interesting area without overelaborating. You can keep coming back and adding darker tones later. Allow areas of light to creep through the darks. Color and detail are important, but take care not to overdo either at this stage.

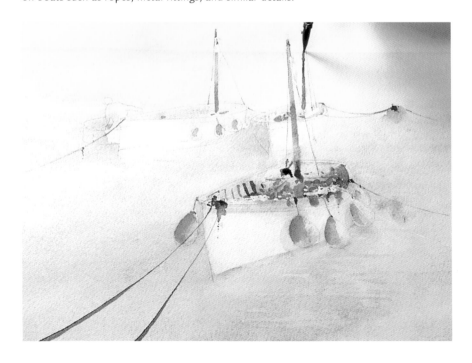

3 Add finishing touches to the surface of the water. Paint masts, ropes, and rigging (see Artist's Note, opposite) from the bottom up, with quick and confident single strokes. Make sure you have enough paint on your brush to complete the stroke. Remember that ropes coming toward the viewer are in perspective (foreshortened) and will appear thicker.

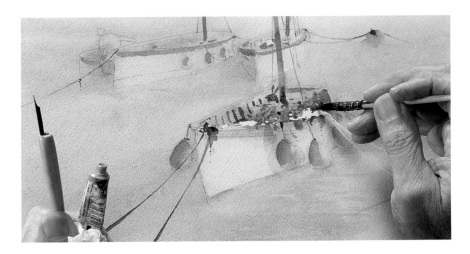

4 Remove the masking fluid with your finger, and keep returning to your complicated areas, adding even darker dots and the odd bright color (perhaps for a life jacket) straight from the tube. Be careful here, as this one element could become the focal point and change the entire painting.

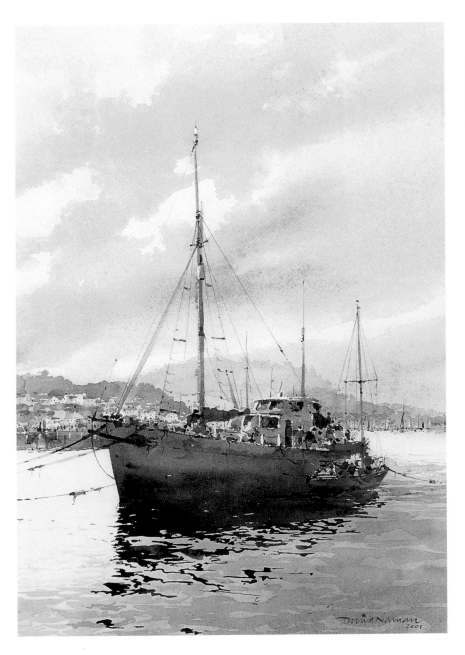

5 In this painting, you can see that the rigging and items on the boat appear complicated but in fact are just a series of tints and marks made with a small round brush. The eye will take in the whole scene and fill in all the gaps and information about boats as if it were all there.

## Q & A

## I want to create convincing sunsets and horizons. Do you have any advice?

**The first thing to remember is that, when you are looking into a sunset, all the light in the painting is coming from one point in the distance, and everything else in the painting tends to be in shadow or in relief. Notice that light is very often captured only on the top edges of foreground hills or buildings, or even people. So once again the first rule is observation.**

1 Wet the paper with clear water, and allow to nearly dry. Have your board at an angle of approximately 10 degrees so the paint runs toward the horizon. Start your sky with a wash of cerulean; as you come down, add some permanent rose and French ultramarine. Reinforce the hills with additional French ultramarine. Add cloud formations by gently wiping a paper towel over the paint and adding some permanent rose on the underside.

2 Using Indian yellow and cadmium red, paint in your sunset while the paper is still wet, and allow to dry. Notice how the colors blend into one another; this is an area of watercolor painting that needs practice before achieving the right results. You will soon learn when to apply these colors so that the right effect is achieved.

3 With a darker mix of Payne's gray, reform the landscape hills. Paint in foreground foliage with a darker color and spits of land into the water, again using Payne's gray.

4 Increase the darkness on the farthest hills, and add more touches of cadmium red to the sun and the ripples in the water. Create some soft edges on the horizon with the use of a soft brush, then paint the hill shadow on the lake with a watered down wash of Payne's gray.

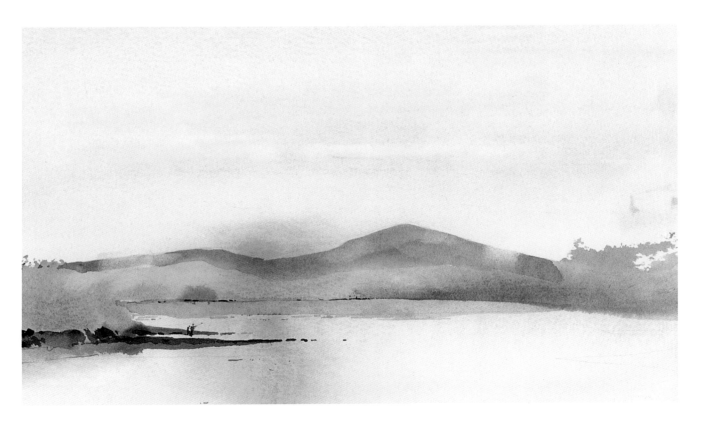

5 The sunset is apparent here and is accentuated by its reflection radiating in the water. This is a fairly mild and gentle sunset. Try applying some darker color and experimenting with all the warm colors and perhaps some pinks in the clouds.

Notice that everything comes together in the finished painting: structure, color, and contrast. Note too how the light has been handled and the delicate but visually powerful way in which the sunset has been conveyed.

# Demonstration: **Boats on a river**

Start by lightly drawing in the general outline of your boats or harbor scene. Do not draw every single rope or wire or every detail of the accumulated paraphernalia on the boats—just lightly describe the areas and compose your picture. Use masking fluid for highlights in one or two areas and on one or two ropes, wires, or masts, but do not overdo this or your final painting will look flat.

1 Paint the initial color wash across the whole page, remembering that the final image is an evening view, and let the colors run into the water. Colors used here are raw sienna, cadmium red, permanent magenta, and French ultramarine.

2 Paint the masts with a strong upstroke as freely as you can. Paint the bow sprit and other details, such as the equipment on deck.

3 Paint in some ropes and the anchor, and start adding more colors to complex areas. Gradually keep adding small dots of color in these areas as you progress through the painting.

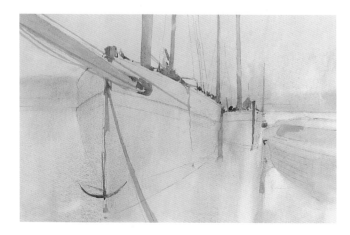

4 You now have a basic outline to work from. The colors you use can be as bright or as muted as you like. Make your choice according to the kind of mood you are trying to convey.

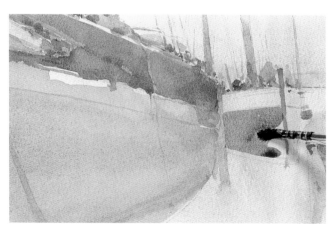

5 Paint in the hulls with a distinctive change of color at the top. The central boat is painted in intense green. This contrast adds impact to the boats and makes them more visually appealing.

6 Paint the bottom of the boats' hulls, allowing the dark mix to form the reflection in the water and obliterating the line where the bottom of the boat meets the water.

7 Paint distinctive meandering lines to show reflections under the stay, emphasizing light between the stay and the boat (look for these images when organizing your painting).

8 Continue painting reflections with a rigger, using a backward flick of the brush to create a ripple effect. Notice the shape of the reflections: they are not simply a series of straight lines and dots.

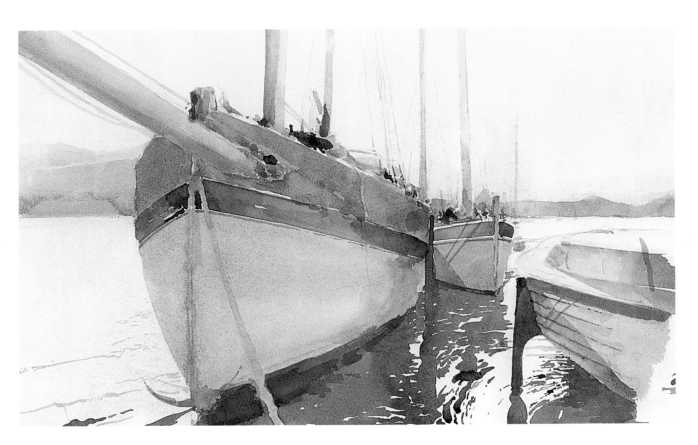

9 Your painting is really starting to take shape now, but it still needs a lot more detail. Compare the step above to the final image, and notice what a difference the extra detailing makes and how the painting gradually comes alive. Note how the painting has been organized and the contrast between the size of the boats. Further detailing will help the scene become more complete.

10 Let the colors dry, then paint a pale blue wash over the entire water area. Allow this wash to dry; then, with a thick mixture of burnt sienna and Payne's gray on the brush, make random smudges on both the ropes and the anchor to indicate debris and seaweed.

11 On the hull of the larger boat, wet the whole area with clear water and drop in some light red, letting it run to suggest rust stains; then let this dry. With a Payne's gray and raw sienna mix, "roll" the brush over the hull to indicate reflections from the water. The scene is already looking more realistic.

12 Paint the side of some card with Payne's gray and apply it to the paper to create rigging lines and ropes (see Artist's Note page 121). Note that thinner ropes can be created by using the edge of the card. As the paint dries on the card, the lines will become more broken. This is a useful effect, as it gives the sense of slight movement in the rigging.

13 Use some color (yellow ochre) straight from the tube to indicate colorful material on the boat, and manipulate it into interesting shapes with the reverse end of your brush. Paint more ropes, and pick out small boats in the distance and other touches to increase interest (rope lines can be created through existing color washes with clean water on a flat brush).

14 Add the finishing touches to the ropes, masts, and any other small details. All these additions will make the final painting look lifelike and authentic. Perhaps darken a section of the mast or make some very dark marks in small areas on the boat.

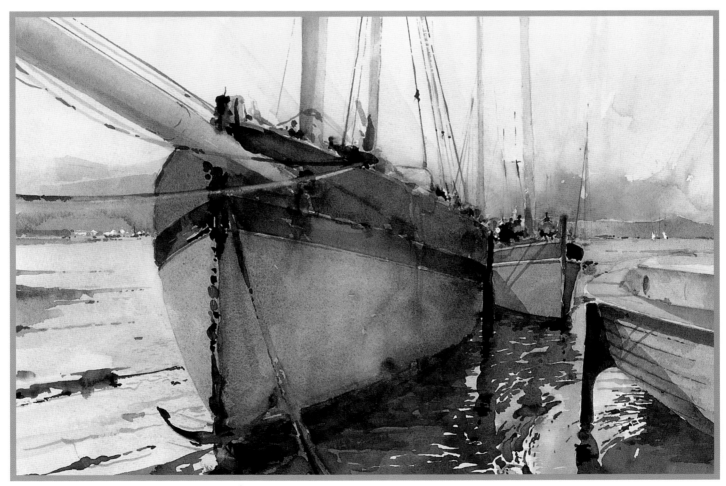

15 The final dusky effect is achieved by wetting the surface of the paper again and applying rose madder to the sky, letting this wash fall onto water and boat surfaces to emphasize the reflections. Note the sense of gentle movement that pervades the entire scene and how this has been achieved. The details on the boats add balance and visual coherence to the whole.

# 8
# Painting people and animals

Painting people and animals was traditionally an area where artists could show off their skills and techniques. The subject was usually posed or seated in a studio, and there was plenty of time to draw and paint under ideal conditions: the subject remained still and generally the light always fell in the same direction. The artist could apply all the skills acquired over years of work to this subject. To a certain extent, this is still true. However, treat this genre the same way you do landscapes or waterscapes, and not spend undue time trying to be too accurate.

Portraits of people and animals can be challenging, but just remember some of the techniques you have learned in other areas of painting. Build up your figure the same way you would construct a landscape or townscape: gradually add washes of darker color to form the overall shape of your subject, altering and changing tones as you progress. Be careful how you position the light that falls on the rounded surfaces of the figure, and try to avoid sharp edges unless they are silhouetting the figure.

Anatomical drawing is a whole world of artistic study and can be a lifetime's work, so do not imagine you are going to instantly produce recognizable figure studies or likenesses.

Do not be intimidated by the subject; allow your paint to run across the surface of your subject as you would in a landscape. Do not draw in fixed lines or areas of color that you feel you have to stick to; and do not try to paint a mouth, eyes, or nose that is exactly like that of your sitter. Just form general shapes and let the viewer's imagination do the rest.

When painting people and animals, keep your brush loaded with paint, and do not get bogged down with picky details, such as eyelashes, the shape of cheekbones, or the lines of all the individual whiskers. Allow your washes and shading to suggest these features.

The biggest danger with this category is to take too long and become labored in your painting and in your attitude toward the subject. As with all areas of watercolor painting, do not be afraid to choose unusual subject matter—people with eyeglasses and unusual features are just as interesting as those with beautiful faces. Another important element to consider is how your subject is lit. Back lighting—where the light coming from behind the subject causes a halo effect (sometimes called *contre jour*)—is particularly effective. Do not shy away from people or animal portraits—you may find it a most rewarding experience.

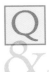

# What is the secret of painting hair or fur successfully?

**The techniques for painting hair and fur are very similar. Firstly, analyze the subject: what does the hair or fur do? Does it form the shape of the head of a person or the body of an animal, or does it seem to have a life of its own? What basic color is it, and what are its lightest and darkest colors?**

1 To begin, apply masking fluid with quick sweeping motions using a crow quill pen on the areas of fur you would like to highlight, such as around the ears, eyes, and more generally on the body in the same way you would apply paint. Then paint wet into wet: once you have wet your paper, apply the palest color of the hair or fur, not allowing any definite edges to form against the background. When this is nearly dry, introduce the next darkest color, again not allowing any hard edges to form. Repeat this process as many times as needed until the right blend is achieved. Allow the painting to dry.

2 With a suitable size brush (even a rigger), paint the characteristic marks of the hair or fur using quick, short strokes to suggest fur, again softening the edges if required until the only marks left to be made are the final hard-edged strands of fur or hair.

3 Rub off the masking fluid with your finger. Paint very fine hair with a fine brush or even a loaded crow quill pen. Keep returning to these areas during your painting to add the smallest marks, such as highlights or distinctive patches to complement the rest of the composition.

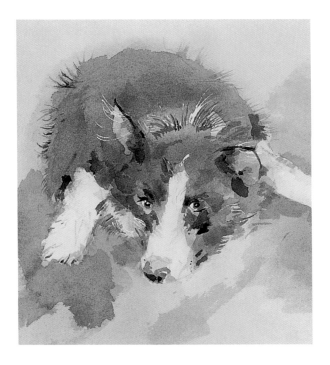

### ARTIST'S NOTE

Hair or fur should not be painted in isolation from the rest of the painting. Build it up together with the other elements—skin, eyes, and so on—so that the whole image is painted as a whole.

4 Here you can see that only an indication of fur is needed because we know it's a dog! Further fine lines of hair could be added, but these would be unnecessary.

# How can I achieve realistic skin tones and shadows?

**Skin tones vary from person to person but there are a few basic rules that apply to most skin tones and shadows. Most important of all is to be observant in studying what color a person's skin actually is and how it is affected by reflected light.**

1  Skin tones vary throughout the world, and you can only attempt to match your tones according to the cast light and the person's natural coloring. To achieve a mid-tone skin coloring, try using yellow ochre with alizarin crimson, adding cobalt blue for darker or shadow areas (under the chin, for instance).

2  Try raw sienna with cadmium red for a Caucasian complexion, but be careful not to slavishly follow this coloring suggestion. There are no hard and fast rules; experiment with color mixes until you get it right. Apply the colors delicately and keep looking at the sitter.

3  For a darker complexion, mix burnt umber with cobalt blue deep, adding Payne's gray and a little cobalt violet for the shadows. Don't forget the reflections of the colors in the rest of the composition—they will have an effect on the choice of your skin tone. Draw a faint line of clear water where the tones merge and, when nearly dry, introduce the darker tone to the lighter where the clear water is drying. The soft edge formed will diffuse the colors in a more realistic manner.

### ARTIST'S NOTE

The shadows on the skin should just be darker versions of the skin tone and can vary in color and shade depending on the light. Mixing shadow skin tones is therefore a question of darkening tones that have already been used.

# Demonstration: Woman with eyeglasses

Some important decisions were made here before starting this portrait. First the pose was restricted to head and shoulders only, with very little background and the possibility of detail in the face and hands only. Then some devices were used to help with the composition: the eyeglasses and necklace are useful additions, providing the opportunity to "frame" the painting and take the eye away from just plain areas of skin. They are also personal belongings that pertain to the sitter alone and help to make her instantly recognizable. Be aware of the effect of light as well, and place it where it can add to the mood of the painting. The light in this instance is coming from a window in front of the sitter, reinforcing the contemplative pose.

1 Complete your initial drawing, and apply masking fluid in the hair, necklace, and eyeglasses with free, flowing strokes. When the mask is dry, wet the entire surface of the painting.

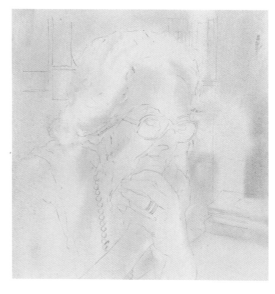

2 Apply the first skin tone when the paper is still damp (yellow ochre and alizarin were used here), with touches of cobalt blue and cadmium red for the blouse and gold ochre for the background color.

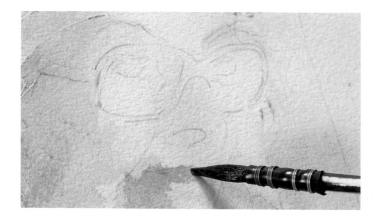

3 Paint in a weak blend of cadmium red for the lips and some shadows on the face and hands with slightly darker mixes of the colors used so far.

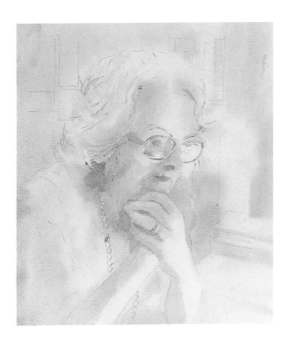

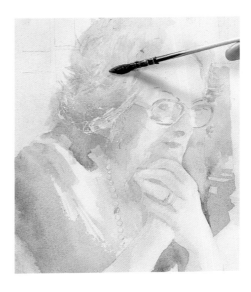

4 The drawing is now fixed and the background strengthened with further touches of French ultramarine. The portrait is beginning to take shape and now needs further color, depth, and detail.

5 Apply light stokes of ultramarine and gold ochre to the hair.

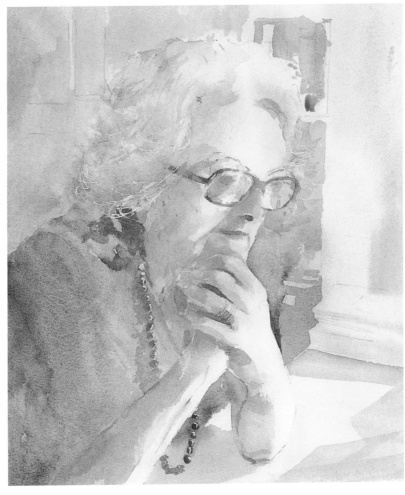

6 Reinforce the shadows on the fingers, eyes, hairline, eyebrows, and background. For shadow colors, use a darker mix of the background color, making sure that no hard edges are created.

7 Allow the colors to dry. The painting is now more defined; the necklace and the eyeglasses have been painted using a burnt umber and burnt sienna mix, and the blue blouse has been darkened with French ultramarine.

8 Remove the masking fluid with your fingers, and darken the background behind the lightest area of the hair to accentuate the light coming from the front.

9 Add further color changes to the hair using any of the "hair" colors already mixed in your palette. Add some white strands using a fine brush.

10 Deepen shadow areas by painting with a stronger mix and carefully removing excess color from the side of the face where necessary with a paper towel. Always keep your brush loaded, even if you eventually need to remove excess paint with a paper towel.

11 Strengthen the shadows in the folds on the blouse. Don't forget to stand the painting against the wall or on your easel and view it from a distance at regular intervals to check the overall design and impact of the marks you are making.

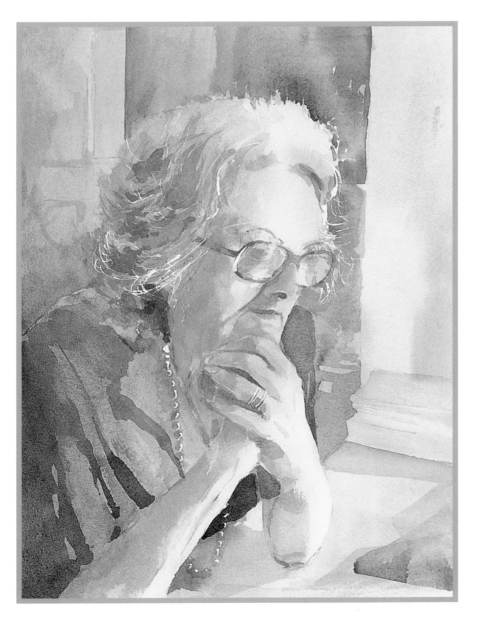

**ARTIST'S NOTE**

If your painting dries out at any time, you can dampen the paper a little using an aerosol spray. The colors may even run a little if the board is tilted when sprayed, generating soft edges.

12 There are always improvements to be made with your final painting, but be careful not to overwork areas that you are not totally satisfied with. There comes a time when you have to stop and leave your painting as it is. The hands and the necklace in this painting could stand some improving, but further effort may make it look overworked.

# What media can I use to achieve a mottled or rutted effect in my paintings?

There are many products on the market for altering or enhancing your watercolors: granulation medium, blending medium, texture medium, gum arabic, and various masking fluids. Homemade watercolor resists, however, can be just as effective. When applied lightly and with a free, flowing hand, candle wax is ideal for achieving texture in hair or fur. Sea salt creates a mottled effect, particularly effective when painting shellfish and uneven surfaces, such as this pot. Approach them with restraint, however, because paintings can easily become overworked.

## SALT

1 This painting of a pot needs a textured surface treatment. Apply the color of the pot fairly generously to the paper. When partly dry, sprinkle sea salt over the surface that needs to be textured. Rub the salt between your fingers as you apply it to make sure there are random sizes of salt on the painting.

2 See how the salt "draws up" some of the paint from the surface. The salt will change color as it soaks up the underlying paint, and you will already begin to see the stippled effect on your painting.

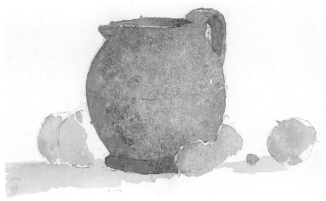

3 When dry, remove the salt by gently rubbing it off with your finger. You may find that some of it is stuck to the paper, but if you are careful, you can rub fairly vigorously to remove final remnants of salt.

4 You can use a hair dryer to speed up the drying process. This technique can sometimes improve the final effect, so it is worth experimenting with. You can always apply further washes on this textured surface without losing the effect achieved.

## CANDLE WAX

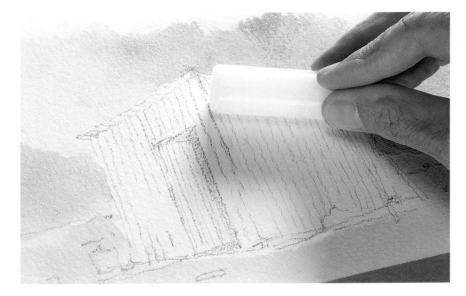

1 For this quick sketch of a corrugated iron shed, apply candle wax in thin lines on the front of the building using the edge of the candle. Then rub the side of the candle on the other side of the shed. The candle wax will resist subsequent applications of paint.

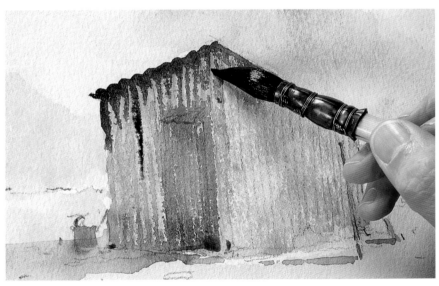

2 Add a dark wash and notice that the wax repels the paint, allowing it to settle only in the indentations in the paper. Drop in some light red, Indian red, or burnt sienna as rust stains. When this is dry you can add more wax to resist on the color you have already used. Here even darker colors have been added to additional wax resist.

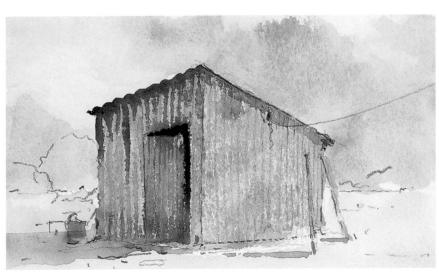

3 Notice that the runs are in straight lines on the elevations (the sides of the shed) where the wax was applied with the candle edge. This is a quick and effective way of achieving an irregular surface area and works especially well on coarser paper.

# Demonstration: **Crab on a beach**

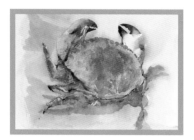

In this painting, various techniques were used to create an accurate rendering of a crab. Masking fluid was used to highlight the lighter areas, and sea salt was sprinkled over the entire carapace to achieve a mottled effect. When experimenting with new techniques, it is not always possible to predict what the final result will be, so it is worth experimenting first on a separate piece of paper until you get it right. It would also be interesting to paint just the shell and perhaps one claw of this crab to emphasize the textures and produce a more abstract completed painting.

1 When your drawing is complete, apply small areas of masking fluid to areas where reflections are likely using a crow quill pen or an old brush. If using a brush, clean it as soon as you have finished or it will be ruined by the masking fluid. When dry, completely wash your watercolor paper with clear water, and allow to dry until just damp.

2 Paint on a random wash of raw sienna, with splashes of burnt sienna, permanent magenta, and French ultramarine mixes on the shell area of the crab, and allow to partly dry. These colors will merge and create a good background color before moving on to the next step.

3 Lay the paper flat; while the paper is still damp, sprinkle on sea salt, crushing some between your fingers to alter the size of the granules. Allow the salt to stray on to the crab's legs as well. Either allow the painting to dry naturally or use a hair dryer.

4 The color is absorbed by the granules of salt, creating random patterns of light and dark hues. Allow to dry thoroughly before moving on to the next stage.

5 Brush off the salt to expose the blotchy paint effect of the crab's carapace. This is another example of taking a chance with your watercolor, as the results cannot always be predicted.

6 Now "redraw" the crab with paint, forming the claws and legs and the edge of the carapace with darker and thicker washes.

7 Add shadows to the back-left quarter of the crab's carapace. This will help define the source of light.

8 Carefully peel off the dried masking fluid, taking care not to damage the surface of the paper. The original white of the paper will now show through wherever the surface has been screened by the masking fluid.

9 Now the contrast between the watercolor washes and the white paper is too great. Blur the contrast between the two by "scrubbing" using a stiff bristle brush and clean water, blotting excess color with a paper towel as needed.

**10** Add shadows on the underside of the crab with a mix of French ultramarine, Payne's gray, and a touch of permanent magenta. Painting in shadows gives the image a sense of solidity and three dimensions.

**11** Strengthen the drawing again with further stronger washes, adding more defined markings on the carapace. It is important to view your painting from a distance at this stage, as the colors may appear too fused and difficult to distinguish close-up.

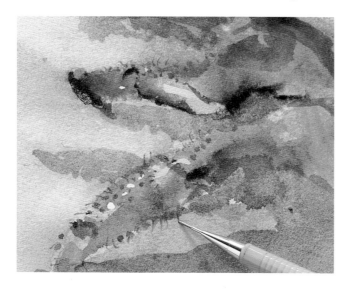

**12** Strengthen the background shadow at the top left of the painting by dragging any excess paint with a paper tissue. Use a pencil to draw in fine hairs on the crab's legs.

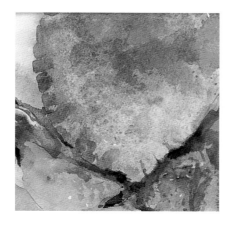

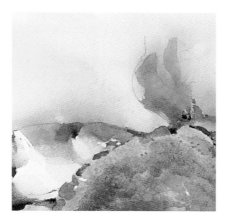

**13** It is interesting to see what abstract paintings could be produced from the interesting surfaces in this painting. Experiment with this holding a cardboard frame around different areas of the painting. (*See* pages 20–21 for details on framing.)

14 Use two thin black card angles to isolate an area of interest possibly for a new painting. You can try this out on almost any type of painting you have completed, but it works best on paintings that feature attractive and unusual areas of color, where the subject cannot always be made out when centered in on.

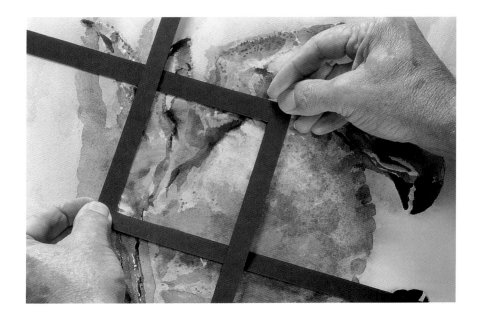

15 This is a challenging painting to do, and it needs to be tackled in a free and spontaneous manner and kept wet all over for most of the time. In order to progress with your painting, you will need to try to control these wet into wet techniques. Although the results cannot always be predicted when adopting this technique, the anticipation of the final result is what painting wet into wet is all about.

# Conclusion

After reading through this book and experimenting with some of the answers and demonstrations, you will see how many of the topics can be grouped into five main areas: approaches, ways of seeing, applications, attitude, and experimentation.

A certain level of aptitude when sketching or drawing is desirable, and you should be constantly practicing your drawing skills. One of the enjoyable offshoots of painting is meeting others who share the same interest. Join a drawing and sketching class in order to meet and exchange ideas and techniques with other artists.

Though watercolor may seem to be simple on the surface, you are now more familiar with some of its complexities. Because watercolor painting is more immediate and spontaneous and you can't change what you've applied as easily as you can with oils or acrylics, a great deal of early planning is required. Artists working in oils can paint over a dark area with a lighter tone as they get further into the painting. With watercolor, however, questions about light and dark areas, quality of underpainting, and so on have to be decided on before you put brush to paper, and so all the creative process takes place in your head at the outset.

Keep your work flat in a drawer and occasionally compare it with what you have learned and produced more recently. Are you progressing toward your desired results, or are you still producing paintings that need some improvement? The purpose of this book is to inspire you and to help you to progress. It is filled with authoritative advice and tips that will help you to achieve attractive and accomplished watercolor paintings. Suddenly you will move to a new phase in your watercolor painting, and your work will be much more rewarding.

# Picture credits

Page 25, bottom, John Newberry
Page 41, bottom, Ronald Jesty
Page 61, bottom, Arthur Maderson
Page 77, Lucy Willis
Page 81, Moira Clinch
Page 83, top, Thomas Girtin

Page 83, bottom, David Bellamy
Page 91, Moira Clinch
Page 99, top, Milton Avery
Page 99, bottom, Margaret M Martin
All other artworks by the author

# Index